Patty **/** Ann

Praise for *Money* **Can** *Buy You Happiness*

"This is a brilliant and passionate book that provides women with all the strategies and tools they need to close the gender wage gap. In *Money Can Buy You Happiness: Secrets Women Need to Know to Get Paid What They Are Worth!* Dr. Patty Ann shares all the negotiating tips and financial information women must know to get paid what they are worth.

"With a straight-from-the-heart practical upbeat and tell-it-like it is style and wisdom, Dr. Patty Ann's book will surely transform your relationship to money—empowering you to increase your bottom line and happiness!"

<div align="right">

Barbara Corcoran
Shark from the famed *Shark Tank Show*
Best Selling Author of *Shark Tales*
Co-Founder of The Corcoran Group

</div>

"Finally! A book that gives women permission to be happy and rich at the same time. *Money* Can *Buy You Happiness: Secrets Women Need to Know to Get Paid What They Are Worth!* is one of the few essential books on negotiation every working woman should have on her shelf. This timely and powerful book deconstructs women's uncomfortable relationship with money, encourages them to seek their true market value, and provides them with a proven step-by-step plan to close their own personal wage

and income gap. Essential reading that could put negotiation consultants like me out of business. Hooray for *Money Can Buy You Happiness: Secrets Women Need to Know to Get Paid What They Are Worth!*

<div align="right">

Victoria Pynchon, Attorney

Negotiation Consultant, She Negotiates Consulting and Training

</div>

"Listen up ladies! It's time to debunk all of your limiting beliefs about money so you can start making MORE! Dr. Patty Ann Tublin has struck a chord in her new book, *Money* Can *Buy You Happiness: Secrets Women Need to Know to Get Paid What They Are Worth!* It's not okay to keep settling for just enough money to "get by." As women, we've been sold a bunch of lies that it's not okay to make a lot of money and that money won't buy you happiness. I've lived both realities and I can tell you that I am a heck of a lot happier knowing that I have the power to make a lot of money, live a great life and give back to the organizations that I care about. If you are ready to change your story about money, then dive into Dr. Patty Ann's powerful, tell-it-like-it-is book—you will be glad you did!"

<div align="right">

Ursula Mentjes, Best Selling Author

"Selling with Intention and Selling with Synchronicity"

</div>

"Dr. Patty Ann does it again in her new book, *Money* Can *Buy You Happiness: Secrets Women Need to Know to Get Paid What They are Worth!* With her urgent, powerful and captivating message, Dr. Patty Ann encourages and empowers women to embrace financial wealth. This phenomenal book provides a proven step-by-step system that shows women *exactly* how to negotiate and get paid what they are worth, while debunking myths around women's financial intelligence.

"As a long time advocate for women taking the first step in demanding what they are worth, it is not enough to sit on the sidelines and talk

about pay inequity. Dr. Patty Ann lays out practical influential strategies for women to negotiate their worth—the most important one being that you *know your worth* and *engage in a healthy conversation about that worth*.

"Unapologetically, Dr. Patty Ann shows the reader how money can provide happiness, contentment, peace of mind, and the ability to have your voice heard on a larger stage. If you are not getting paid for your value, it's your responsibility to make sure you do by reading *Money Can Buy You Happiness: Secrets Women Need to Know to Get Paid What They are Worth!*

<div align="right">Julie Smolyansky President of Lifeway</div>

Patty Ann

Money *Can* Buy You Happiness

Secrets Women Need to Know to Get Paid What They Are Worth!

Dr. Patty Ann Tublin

Motivational PRESS
LEADERS IN GLOBAL PUBLISHING

Published by Motivational Press, Inc.
1777 Aurora Road
Melbourne, Florida, 32935
www.MotivationalPress.com

Copyright 2016 © by Patty Ann Tublin

Manufactured in the United States of America.

ISBN: 978-1-62865-265-9

Contents

Patty / Ann

This book is dedicated to my husband Mitch
who is, quite simply,
The very best thing that ever happened to me!

And to our children:

John, Bryan, Neil & Eileen

My love for you is without limits!

My wish for you is to
Live life fearlessly and without regret –
There are no do-overs!

ACKNOWLEDGMENTS

As is true for most things in life, this book would not have been possible without the unwavering love and support of many people. First and foremost, I must thank my husband Mitch, who, once again, has championed me through thick and thin while researching and writing this book. Loving me is anything but a walk in the park, and yet you unconditionally continue to do so. Well into our third decade of marriage and friendship, you remain the wind beneath my wings!

I would also like to acknowledge my four children: John, Bryan, Neil, and Eileen, who at the commencement of the writing of this book are well on their way to making their unique mark in this world! You are four different and yet fundamentally very similar Millennials who are as passionate about loving and supporting each other as you are about making the world a better place. Could being your mom get any better than that? I love you with all my heart, and Dad and I are so very proud of you. The world is yours to explore love and behold—take it by storm! My wish is for you to continue to love, support, and champion each other, no matter what the future may hold!

Since this book reflects my passion for helping women close the gender pay gap and get paid what they are worth, I would be remiss if I did not thank all the hardworking women out there who are our mothers, wives,

daughters, sisters, daughter-in-laws, aunts, nieces, and cousins, who work hard every day to make their lives, the lives of their loved ones, and the world a better place. I'm not joking when I say if women ruled the world, "Oh what a wonderful world this would be!"

Many of the same cast of characters and friends (and you know who you are) have seen me once again go underground in the evenings and on the weekends while writing this book. Thanks for your understanding and support, and for putting up with my crazy work schedule. Now that I've resurfaced, rumor has it my friends are asking when I will go underground to begin my next book!

Finally, I must thank my parents, Jack and Carole Ann Twomey, both of whom have passed on. As each year passes, I realize more and more how far ahead of their time these two loving, hardworking, blue-collar people were. They never once made me think any door was ever closed to me in any way because I was a girl! It never dawned on me that being a girl or a woman would limit my opportunities or financial rewards. It truly never crossed my mind. I believe it served me quite well to be totally ignorant of the prevalent gender bias in the workplace and the world that has held back so many women from reaping their just rewards.

FOREWORD

This is the book generations of women have been waiting for, a treatise that reveals not simply the "why" of gender wage gaps and the systemic challenges that continue to dog "women's work," but the "how" of revolutionizing the way in which women acquire and exercise power.

As Gloria Steinem said more than forty years ago, "The truth shall set you free, but first it will piss you off." * She didn't say, "The truth shall set you free and then you'll be angry forever," or "Become a collector of grievances," or "We should get angry and then wallow in our own resentful juices."

She said we'd be *free*.

Free of the internal demons that tell us to be grateful to be let in the door, to sit quietly and hope for a just reward, to be modest and receptive rather than proud and assertive. Free to seek compensation, promotions, market-rate fees for our services and prices for our products. Free to assert our true market value in the hands of another, to insist that we're capital investments rather than empty costs on the wrong side of the ledger. Free to leave someone else's employment and start our own businesses. Free to code, obtain venture capital, or run for office. Free to assert that parenthood makes us better, not worse employees. Free to ask questions and, from time to time, take prisoners.

* http://quoteinvestigator.com/2014/09/04/truth-free/

My business, She Negotiates Consulting and Training, charges our individual clients thousands of dollars for the kind of consultation you'll find in Dr. Patty Ann Tublin's book. Maybe you've read the groundbreaking *Getting to Yes* or *Negotiation Genius* or *3-D Negotiation*, all by the best male minds in the business. Those books and the thousands like them haven't opened the floodgates of women's vast potential to negotiate on their own behalf. They don't address subtle gender biases, which reward men for potential and women for performance, and which create a gender wage gap of seven to fourteen percent between childless women and mothers. They do not nest their business or career advice in women's gendered workplace experiences.

This book, however, does precisely that.

And when we earn what we're worth, we practice what we're stereotypically inclined to do—spend our money on health care and education and charity. In *The Chronicle of Philanthropy* Holly Hall noted in 2010, for instance that "women at every income level give to charity more often than men do, and they tend to donate more money on average than their male counter parts."* Women's tendency to spend for the benefit of the "tribe" has been most widely recognized in microloan practices. According to Muhammad Yunus, the Bangladeshi professor-turned-banker who has been called the father of microcredit,

> *[Women] did not squander their money on snacks or luxuries as men did. Instead, they used their funds to buy some chickens, a cow or some seeds. They put the money they made selling the resulting vegetables, eggs or milk into providing more food for their malnourished children or to sending them to school. Thus, they were able over time to improve their families' diet and education, contributing to the cycle of poverty alleviation.*

*https://philanthropy.com/article/Most-Women-Give-More-Than-Men/159623

Unsurprisingly, women micro-borrowers were also far more likely to repay their small loans than their male counterparts.

Ever-greater numbers of women are recognizing, and acting upon, the undeniable fact that poverty is a women's issue. As the National Women's Law Center reported in 2013:

> *Nearly six in ten poor adults are women, and nearly six in ten poor children live in families headed by women. Poverty rates are especially high for single mothers, women of color, and elderly women living alone.*

This year, that same organization reported, "women are nearly two-thirds of minimum wage and tipped workers." Many of us remain stuck in "women's jobs," reaping the minimal rewards that go with them, as secretaries, nurses, teachers, and cashiers, in that order.

I cite these statistics in this Foreword to Dr. Patty Ann's book because women like Dr. Patty Ann Tublin and me—highly educated, white, female professionals—have been condemned for failing to "check our privilege" and accused of serving only our own needs.

Dr. Patty Ann's book is not, however, pitched only to the privileged among us. Women at every socioeconomic level and in every job can use the tools contained here, whether that job be in professions, business, skilled trades, unskilled labor, or government work. Admittedly, some jobs, like those at which women labor for minimum wage, are not likely to yield greater benefits or higher wages without the type of concerted effort waged by organizations such as the activist group Raise the Minimum Wage. Even though this book is not about activism, it is about the acquisition and exercise of power by and for women. And when women earn their place at the table and their fair share of the nation's wealth, they become a rising tide that lifts all ships.

Take this book and use it not simply to increase your own welfare and that of your family, but the well-being of all women everywhere, particularly those who have no access to any avenue of power. As my friend Gloria Feldt, the leadership expert and author of *No Excuses*, writes:

> *Here's what's so exciting today: Women are transforming the power paradigm. I have a concept I call "Sister Courage." It has three parts:*
>
> - *Be a sister. Reach out to another woman to offer help. Ask for help when you need it. Don't let yourself be isolated or try to solve all problems by yourself.*
>
> - *Have the courage to raise the issues that concern you. Do you think there is a better way to solve a problem or design a product? Do you want to negotiate flex time so you can see your children more?*
>
> - *Put the two together with a strategic plan to lead to the change you want to see in your workplace.*
>
> *That's Sister Courage. And with it, you can change your workplace, your life, and your world.*

If you've picked up this book, you've already decided to ask for help when you need it. When you read this book, it will give you the courage and the tools to raise the issues that concern you. And when you put those two activities together, with Dr. Patty Ann's Tublin's valuable advice, you will be the change you want to see in your workplace, your life, and your world.

Go get 'em. The world is your oyster.

<div align="right">

Victoria Pynchon, Attorney
She Negotiates Consulting and Training

</div>

INTRODUCTION

The famous motivational speaker and self-development guru Zig Ziglar states, *"Money isn't everything, but it ranks right up there with oxygen!"*

From the cradle to the grave, you've been given the message, covertly and overtly, that money cannot buy you happiness. It's been so ingrained in your head that if you are a typical woman living in American society, your mindset, belief system, and monetary personality has created an avoidance of, if not downright aversion to, any conversation surrounding money, finances, and investing.

Americans have been told, "You can't buy happiness" and, "Money is the root of all evil." Women, unlike men, have bought into this mindset hook, line, and sinker. University of Michigan economists Justin Wolfers and Betsey Stevenson performed a study in 2013 that argues against the above points. Susan Adams writes in Forbes.com:

> *Relying on worldwide data from Gallup and other sources, Stevenson and Wolfers determine that the wealthier people are, the more satisfied they are with their lives, at least when you look at nationwide figures. They also find, contrary to what many*

economists believe, that there is not a point of wealth satiation beyond which happiness levels off.

If I were to ask what keeps you up at night, I bet you eight out of ten times the answer relates to money, and not having enough of it: to fix the car, pay the mortgage in a timely manner, put the kids through college, etc. Money can eliminate these specific types of fears. Research shows money also increases your overall sense of well-being by diminishing stress in your life.

Money is such an essential commodity to life because it *can buy you out of the stress you feel from not having enough money.* What if the greatest contribution to increased happiness in your life is the ability to gain access to more money?

If you think money cannot buy you happiness, I urge you to think again. Money *can* buy you happiness, as long as you don't become consumed by it, or a slave in its pursuit.

Okay, I Believe You! How Do I Make More Money?

Let's say I've convinced you, or you've already convinced yourself. If you made more money, you'd be happier, you know you would. People say money doesn't make you happy, but you're thinking, "Yeah? Try me! I know it would help put me in a much better mood!" But you may be crippled in your ability to get paid what you are worth on the job, lacking the skills and the courage to negotiate for more.

You may be financially illiterate.

You may be unable to have an intelligent conversation about money with your spouse or business partner.

You may be afraid to raise your prices in your own business.

You may be divorced or widowed, and not only is your emotional loss enormous, but now you are in big trouble because you were financially in the dark, and somehow, in an instant, you're supposed to know how to

manage the finances of your household when you don't even know how to balance your checkbook, or what's in your bank account.

You may want to plan for your retirement, but you haven't a clue how to get started.

And more . . .

I've been a relationship expert and corporate consultant for more than twenty-five years. Thousands of single, married, separated, and divorced women, both professional and entrepreneurial, have shared with me their most intimate troubles, many of which are rooted in ignorance of financial literacy. It totally astonishes me to consistently meet smart, sophisticated, highly educated women who are otherwise confident in their chosen professions and careers, but who act coy around the conversation of money. These are successful, vibrant, brilliant women who are not getting paid what they are worth and deserve, and who choose to remain totally ignorant of their personal and family finances.

Why is this? You've been socialized since birth to avoid the topic of money, lest you be seen as greedy or, heaven forbid, as wanting to make a buck!

It's tempting to blame others, this target called "society" or external circumstances seemingly beyond your control.

But you really have no one to blame when you continue to remain financially illiterate by avoiding educating yourself.

You bought this book for a reason. You are ready to launch yourself out of being naïve, fearful, uneducated, and frightened by any topic that involves money.

Maybe you are aware of this fact: Ten years into their careers, women earn twelve percent less than their male colleagues, according to research done by AmericanProgress.org. This pay discrepancy between men and women continues at the graduate school level, where "Catalyst research

found that women MBA(s) were being paid, on average, $4,600 less in their first job than men."_

Are you going to allow yourself to be one of those women?

Listen to these theories that researchers suggest explain the ongoing gender wage gap:

*Women traditionally take on more of the household responsibilities than men.

True.

*Women tend to interrupt their careers more than men to have children and/or take care of their elderly parents.

True.

*Women are more inclined to work part time than men.

True.

*Female-dominated professions, such as teaching and nursing, tend to pay less than male-dominated professions, such as engineering and financial analysis.

True.

Given the considerable validity to the above reasons explaining the gender wage gap, why is it that according to AmericanProgress.Org, "forty-one percent of the wage gap is still unexplained by measurable factors"?

I'll tell you why. *Because women like you, and thousands of others I've worked with over the years, are afraid. Money is a dirty word.* Asking for what you want and deserve is hard. The gender gap continues because you are under the influence of a societal bias, true. Even if men and women hold the same job and have the same background, with all other things being equal (which of course they never *really* are), the gender wage gap remains alive and well for modern American women across the board.

How long will you pay the extremely high cost, both financial and emotional for your financial ignorance? In modern American society, two-thirds of you are the primary breadwinner or co-breadwinner for your family. You aren't only working because you enjoy it, your mortgage, the kids' school tuition, the groceries that go on the table are being paid for from your hard work. You aren't just earning "extra spending money" or mani-pedi money anymore. You are bringing home the bacon, and the whole meal, and it's about time you got a grip on what's holding you back from being paid what you deserve and/or charging what you are worth.

Why does this societal norm of paying women less than they are worth continue?

I don't need any fancy researcher to tell me what I already know as an entrepreneur, corporate consultant, and licensed therapist. You, and millions of other women, have allowed it to persist! Yes, let's call a spade a spade. In the final analysis, the buck ultimately stops with each one of us! Just as a marathon begins by taking the first step, *if we want society to pay women what women deserve, each individual woman must take the first step by demanding she gets paid what she is worth and refusing to accept anything less!*

Until you and every other working woman unequivocally refuse to accept less than that, the pattern discovered in 2012 by Catalyst.Org will continue. Full-time working women will make 77 percent of what full-time working men earn.

Aren't you sick and tired of putting up with this? Just because it's the norm doesn't mean that it should be, or that it's right, or that it can't change!

As a professional speaker, I'm always amazed when the women's networking groups of Fortune 500 and Fortune 100 companies ask me to speak at their women's events and then proceed to tell me they have no

budget for my services. But would I speak anyway? Seriously? You have no budget for your women's organization? What does that tell you about the company's *real* commitment towards their female employees' professional development? And perhaps just as importantly, what does that tell you about the managerial women in these companies that allow for this lack of funding? Think about this. Do you think any male employee of any company would allow their professional male groups to go unfunded? Would a male speaker be asked, or expected, to speak without being financially compensated for his professional services? The answer to these questions is a resounding "No!" Women, however, are asked to do this all the time, and they allow it to perpetuate. This infuriates me!

So I ask you: Will you continue to make excuses for being underpaid by keeping your head buried in the sand of financial ignorance, while mumbling to yourself and anyone else who will listen about how unfair the gender wage gap is?

Or will you be the change?

My work as a corporate consultant and executive coach has introduced me to countless executive and mid-level management women who are fully cognizant of the fact they are being underpaid compared to their male colleagues.

Wake up. Avoid a financial shipwreck. Take charge of your financial life!

Chapter One begins with an exploration of the childhood influences and social conditioning that color everything you think and know (or don't know) about money, including your attitude and mindset toward money. It explores how our reluctance to embrace financial knowledge hinders us in both our careers and our marriages (romantic relationships). It addresses why it is so difficult for women to ask for a raise or increased responsibilities at work, while also exploring how the "good girl" syndrome cripples our ability to advocate for ourselves in the professional arena. It

shows how money can, indeed, buy you happiness by increasing your overall sense of well-being.

Chapter Two discusses the ten most common reasons why women are underpaid based upon current research and my professional experience as a corporate consultant for over two decades. We will look at how your limiting beliefs about yourself and the value of your work inhibit you from asking for pay raises and/or negotiating salaries. When I challenge women as to why they allow their own individual wage gap to persist, they reply: "Well, I don't want them to think I'm being greedy," or, "I'm okay with it, it's not like I'm not getting paid well." Compare this attitude to a man's, who would never in a million years allow a discovered wage gap between himself and his peer (of any gender) remain unaddressed! Furthermore, I have never met a man who thought he was overpaid! And believe me, you and I have both met plenty of them!

Chapter Three will explore how women's unhealthy relationship to money is rooted in a negative money mindset. This mindset fundamentally inhibits women's ability to ask for and hence get paid what women are worth. Exercises are provided that allow you to create your own healthy affirmation about money. These affirmations will facilitate your transformation from a negative money mindset to a positive money mindset.

Chapter Four provides proven and realistic negotiation strategies and tools that will empower you to successfully negotiate your salary (and benefits and perks) so you get paid what you are worth! It will also shed light on the differences between how men and women negotiate.

Chapter Five provides information and exercises that will reveal your "Money/Financial Personality," allowing you to understand your comfort level with debt and savings.

Chapter Six will help you significantly increase your "Financial IQ" by providing information and worksheets needed to create a budget. Fixed

costs vs. discretionary costs will be defined, along with the discovery of one's spending habits.

A list of seventy-eight basic financial terms and definitions essential for beginning your journey towards financial fitness and empowerment is provided to make smart decisions about money and your financial investments.

When you seize the helm of your financial life, and stop falling asleep at the wheel, or letting someone else drive, your happiness will grow with your bank account. Yeah, I've heard what they say: "Money can't buy happiness." Well, let me tell you first hand, "they" are dead wrong!

You know who probably came up with that clever line? A man who was fairly and generously paid for his time!

Money can buy you happiness, and for those unhappy times in your life, money can make them a whole hell of a lot easier too! You're not going to believe how much you'll discover and how much fun it will be when you are financially savvy.

Here's a different quote for you to consider: Ghandi said, "You must be the change you want to see in the world."

Stop bitching about how unfair monetary inequity is. You don't have to accept this norm for your life. You can change it; I'll show you how!

CHAPTER 1

Where It All Began: The Roots of Your Money Attitude

"You have the power over your mind—not outside events. Realize this, and you will find strength."

—Marcus Aurelius

Y ou would think M-O-N-E-Y is a four-letter word the way some women steer clear of any conversation that involves saving, investing, and/or earning it! It's almost as if we're afraid we will be viewed as Jordan Belfort, played by Leonardo DiCaprio in the movie *The Wolf of Wall Street*, the greedy and vile character who will do anything and destroy anyone who gets in his way of making a buck. Rather than acknowledge the simple truth that money does indeed make the world go round, most women prefer to remain ignorant of the financial realities of the world at large.

And yes, I say that they *prefer* to remain ignorant, not just that they haven't had the benefit of financial education, or that in our sexist world women aren't taught financial realities the way men are. It's more than that. What I see over and over again is that women are *choosing* to live their lives fairly clueless about financial understandings and mastery.

This choice has devastating consequences for many women. It's more than missed opportunities to make a buck. It can also have disastrous ramifications when a woman is oblivious to her financial situation, in the event of becoming widowed, divorced, or, yes, married. Additionally, a woman with a credit card or two or three or four who uses it regularly without any real understanding of its impact on her financial well-being can lead herself and her family on the fast track to bankruptcy if she's not given a wake-up call before it's too late. Many families are only one lost job away from financial ruin.

Consciously or unconsciously, women leave money on the proverbial table at work and at home. At some deep level, they have *chosen to remain financially uninformed.* It's almost as if they think it is illegal or immoral to desire and work for wealth accumulation. In many marriages, women either keep themselves totally in the dark or allow their partners to keep them shut out from the realities of their financial portfolio. Here are just three clients I've seen in my practice that exemplify the consequences of this financial ignorance:

After seven years of marriage, Sally divorced her husband when she discovered he was having an extramarital affair with his coworker. While gathering the family's financial documents for divorce proceedings, Sally was shocked to learn they were on the verge of bankruptcy due to her husband's gambling addiction, of which she was totally unaware, because she never looked at any of their financial statements.

Beatrice epitomizes the shopaholic woman. She shopped retail, wholesale, fire sales, and any other sales she could find. Her purchases were often frivolous and impulsive. After all, how many red handbags does one woman really need? When her husband

Tony lost his job, Beatrice was faced with what she perceived to be a daunting task, curbing her spending and learning to become a smart consumer. For the first time in her adult life, it was imperative she understand the concept of budgeting and fiscal discipline.

Alice was tragically widowed when her husband Mike passed away of a massive heart attack when he was only 47 years old. It wasn't until after the funeral that Alice learned Mike cancelled his life insurance policy a few years back when financial times were tough, leaving Alice with a huge mortgage and two middle-school-aged children to support.

Women, Money, and Societal Messages

Contrary to the universal message given to women that "money cannot make you happy" and "all you need is love," several current economic researchers have proven otherwise. Economists Wolfers and Stevenson from the University of Michigan performed a recent study showing a high correlation between income levels and reported levels of happiness. Susan Adams wrote in Forbes.com that the nationwide data from Gallup and other sources have determined that the more money people have, the more content and satisfied they are with their lives.[1]

Additionally, they did not find a wealth satiation point at which happiness levels off, contrary to what many people might have us believe. Discussing this study in *The Atlantic*, Derek Thompson states, "Richer families tend to be happier, and no, there is not an automatic cut-off point," which has erroneously been reported at $75,000 for Americans. This study provides startling proof of the high correlation between money and happiness.[2]

1 http://www.forbes.com/sites/susanadams/2013/05/10/money-does-buy-happiness-says-new-study/

2 http://www.theatlantic.com/business/archive/2013/04/money-buys-happiness-and-you-can-never-have-too-much-new-research-says/275380/

In other words, rather than believing "More money, more problems," the reverse seems to be true—more money, fewer problems, and more happiness!

In the greatest country in the world, where women are afforded freedoms unprecedented anywhere else on the planet, we keep ourselves financially in the dark. But it's a prison of our own making, and we can open the door and bring in the light!

It Goes beyond Your Personal Bank Accounts

Women's reluctance to deal with financial matters and M-O-N-E-Y extends into the workplace and their jobs. Women do not exactly do a 180-degree turnaround regarding their attitude towards money when it comes to their work. In fact, many women fail to negotiate their salaries or bonuses throughout their career because, as many professional women have told me, "Yeah, well, money is not my driver for this job." Or, "I'm not really doing this for 'the money.' I just want to do a really good job!" Really? You are *not working for "the money"*? Why the hell not? Every man on the planet is working for *"the money."* Why do women feel they have to apologize for wanting a big paycheck and/or perks and benefits that reflect their worth? Ironically, women "not getting paid enough is one of the three biggest work frustrations that were cited in a recent Citi/LinkedIn survey of nearly 1,000 professional women."[3]

The data clearly shows women are underpaid at work, regardless of their education, background, etc. It's incredible to think that 66 percent of the approximate amount of U.S. personal wealth is controlled by women. Seven trillion dollars of U.S. consumer and business spending is directed by women, with female baby boomers holding the number one position for spending clout in the United States, according to Kathryn Karlic, Chief Investment Officer at Wilmington Trust Investment Advisors. Yet

3 http://blogs.wsj.com/atwork/2013/05/30/you-wont-get-a-raise-if-you-don't-ask-for-one/

women continue to shy away from the conversation of money both at work and at home. It's as if we have to apologize if we were to admit we enjoy earning money, and we like its buying power!

Historical Influences Shaping Our Attitude about Money

Conscious and unconscious attitudes about money are internalized by approximately age twelve, formed by the experiences of our childhood. Our parents and society at large covertly and overtly communicated money values to us. How our parents discussed or, more often than not, fought about money while growing up conveyed many subtle and not-so-subtle messages about money to us. What money should be used for, how it should be spent or saved, what purchases or life experiences (i.e., lessons, activity fees, membership fees, vacations, etc.) are worth spending money on (and how much money), and what would be considered a total waste of money. Witnessing or overhearing these discussions (or fights between our parents) helped form our monetary blueprint and attitude about money to this very day.

Additionally, women's attitudes about money are fueled by our social conditioning, which internalized the value that good girls shouldn't "ask for anything," lest we are viewed as being too aggressive or pushy. This conditioning shows up in many ways in our adult lives, but perhaps nowhere near as prevalent as in our downright discomfort for insisting we get paid what we deserve, or, in the case of entrepreneurial women, that we charge what our services are worth. Women have been given countless verbal and non-verbal messages that have contributed to the creation of a negative mindset and attitude about money, leading to female financial illiteracy that crosses all socioeconomic levels. See if any of these messages ring bells with you:

1. A False but Highly Seductive Message

Women have been socialized, and I would also say seduced, with childhood messages of "Love will pay the rent." This message cripples women's financial literacy, because as children, we were lead to believe that Prince Charming on a white charger was coming to sweep us off our feet, leaving us to never have another financial worry for the rest of our lives. The majority of girls who bought into this message (and why wouldn't we?) unceremoniously discover in marriage years later that Prince Charming was a fraud, a cheat, or a flirt, who left her for the other woman and took all their money with him; and who is now telling her, regardless of any previously agreed upon arrangement, to "get a job." This is a classic case where *ignorance is totally not bliss.*

2. The Need to Be Liked: An All-Consuming Albatross around Your Neck

Another remnant of our childhood that contributes to our negative money mindset is the *profound need to be liked.* Everyone wants to be liked, and to say otherwise is disingenuous. For many girls, this desire takes on a desperate quality. Peer pressure ignites this fervent flame and is stoked by the positive reinforcement girls are given by their parents, teachers, coaches, spiritual leaders, and other authority figures in their lives, people whom these young girls also want to please. While growing up, society gives girls the subtle and not-so-subtle message(s) they will be liked if they do or don't do the following (although this is by no means an exhaustive list): smile, share, cooperate, be considerate of others, act like a young lady, don't be too pushy, don't be aggressive, don't be bossy—do, do, do, don't, don't, don't. The list of do's and don'ts is endless.

A few years ago, an experiment was designed to test how men and women were perceived in the workplace. A study was created by New

York University Professor Cameron Anderson and Columbia University Business School Professor Frank Flynn. Unfortunately, the results confirmed what many professional women already know. *Likeability is attributed to successful men. The more successful men are, the more likeable they are perceived to be.* Incredibly, *for women, the inverse is true. The more successful women are, the less likeable they are perceived to be!* Therefore, the burning desire by girls to be liked and to be seen as likeable becomes an inherent internal conflict for women in the workplace. Our need to be liked and be seen as part of the "in crowd" does not magically disappear when we enter adulthood. It acts as an invisible and often undetected barrier (even for the woman herself) as she forges her climb up the corporate ladder. (More on the concept of likeability and success for women in business in Chapter Two.)

On a side note, the desire and need to be liked is deeply ingrained in young girls, accentuated by peer pressure. This often becomes the driving catalyst behind transforming the preschool "good girl" into the tween and teenager "mean girl. " This helps explain the ubiquitous bullying behavior we witness within schools—it is carried into adulthood and perpetuated in the workplace.

3. The "Good Girl" Syndrome

Another societal message contributing to our negative money mindset is the *"good girl" syndrome.* It prevents women from getting paid what they are worth throughout their professional careers. The high value placed on being the "good girl" runs rampant throughout women's lives. It begins in preschool and extends throughout high school (and even into college), with teachers, coaches, and youth leaders praising and rewarding "good girl" behavior.

So what exactly does "good girl" behavior look like? It's demonstrated by girls who follow the rules, wait their turn, stay in line, play fairly, share,

seek consensus, accept authority, maintain (and not challenge) the status quo. Teachers tell parents their daughter is a "good girl" because she: "never gives me any trouble," "always does what she is told," "cooperates," "helps others," "is patient," etc. Adults and society reward "good girls" in many tangible and intangible ways; perhaps the greatest prize awarded them has to do with the encouragement of friendships. Adults encourage other girls to befriend the "good girls" because they are "so nice" and "don't cause any trouble." To put it quite simply, "you" will enter the ranks of the "good girl" too, if you are seen with a "good girl"!

The ability to develop friendships cannot be understated as a major developmental childhood milestone. It impacts one's self-esteem, not only in youth but also throughout one's life. Speak to any woman who experienced the exclusion and isolation attributed to a lack of friends during her childhood (for any reason), and her pain will be palpable. It leaves an indelible mark on one's psyche; regardless of how many friendships one develops later in life.

Adult "good girl" behavior is exhibited by women who are people-pleasers and consumed with perfectionism. In their attempt to please everyone, women sacrifice their own happiness and voice in their relationships and marriages. In the workplace, this "good girl" behavior makes it extremely difficult, if not impossible, for women to advocate for themselves, lead, take initiative, and ruffle feathers when it is appropriately called for. These inabilities significantly contribute to the abysmal representation of women in the C-suite and on the Board of Directors for major corporations.

4. The Double Standard for Ambition

In youth, labeling a girl a "trouble maker" is considered a much greater transgression than giving a boy the same label, often with a wink and a nod. All sorts of behavior are considered rambunctious and inappropriate for girls, but when demonstrated in boys are chalked up to "boys will be

boys." When boys become men and leave the playground or athletic field for the workplace, this aggressive behavior continues. It is often rewarded with higher compensation and greater responsibilities. Words such as: "aggressive," "fearless," "ambitious," and a "go-getter," when attributed to men, are quite complimentary. These behaviors are not only *desirable* for men, they are actually favored, if not actively recruited for. Conversely, using these same words to describe a girl at play and a woman in the workplace may be viewed as derogatory, resulting in mixed reviews and perhaps having the woman perceived in the most unflattering way: "bossy." Ambitious women in the workplace are often told to outwardly curb their ambition, lest they be viewed as too pushy and aggressive. An ambitious man would *never* be given this same career advice.

Why is It Acceptable for Women to Work as Hard as Men for Less Money?

Understanding the above messages given to women beginning in childhood provides some insight into why women at work hesitate to ask for *more* of anything, especially compensation. Asking for more money or responsibility at work risks women being disliked and goes against their childhood "good girl" scripts.

Contrast this with how women are viewed when doing work that is traditionally not highly compensated. Professions such as teaching, nursing, social work, and other helping professions are encouraged for women. Why? These professions mirror and fit the narratives of the societal role women are comfortably viewed within. They represent women in the traditionally noble light of helping others and positively contributing to society. In other words, these professions represent the work nice girls do and are not ranked among anyone's list of the highly compensated professions. More to the point, these professions allow women to work hard for little money—the "good girl" syndrome extraordinaire at work here!

Pause for a moment and think of all the positive things women do with their earned money. Research shows women make their communities a better place when they own their own businesses. Why? Because women are more apt to put their profits back into their families and communities to improve their standard of living, rather than keep the profits for themselves. Women are far more likely than men to spend money on others: their families, their communities, their charities, their religious institutions, etc., than themselves.

Due to the generous nature with which women share their earned money, I'm often left scratching my head when I think how society thinks it's great for women to work for less money. There is absolutely no part of being underpaid (or of maintaining financial inequality) that enhances anyone's life, or the world at large.

Absolutely nothing good comes from being poor or struggling to pay your bills. Nobody's overall well-being is enhanced when people are underpaid and overstressed about lack of financial resources. Yet the societal message women are given is that we are "supposed" to work to make the world a better place, while men are "supposed" to work to make money.

Can Money *Really* Buy Happiness?

In Elizabeth Dunn and Michael Norton's book *Happy Money: The Science of Smarter Spending*, they suggest that it's not the accumulation of "stuff" money can buy that adds to one's happiness; rather, it is accumulating *life experiences*, i.e., taking vacations, experiencing a great meal, etc. In other words, buying experiences, which of course require money—rather than purchasing material goods—increases one's happiness, which fuels the premise of this book. Access to a certain amount of money—for most people this access is granted through their paycheck—can indeed buy you happiness. You need money to buy food, whether you are making a great

meal at home or going to a five-star restaurant. Vacations require money, whether you are taking public transportation to a local beach or flying to a platinum-level beach resort. We can all fondly recall The Beatles song with the words "All you need is love," but watch that love fly right out the window when money gets tight and the bills go unpaid (regardless of the reason). Trust me, I've been a relationship expert who has helped couples for almost thirty years, and you cannot imagine the amount of pain I've seen and heard related to money troubles. These two couples come to mind:

Sarah and Bob were an Ivy-League-educated couple living the good life in Connecticut when Bob lost his finance job on Wall Street. For the very first time in their married life, Sarah and Bob began to fight about money. Initially these were small spats, but as Bob's unemployment entered its second year and their finances became exceedingly tight, this couple found themselves on the verge of divorce due to the escalation of fighting corresponding to their diminishing bank account.

Colleen was a CPA married to a blue-collar worker who made less money than she did. Colleen was fine with being the primary breadwinner until the birth of their first child. Immediately after giving birth, Colleen decided she really wanted to take a full year off from work. She found this financially unrealistic due to her husband's considerably lower income. With much reluctance, Colleen was back at work three months after the birth of her baby. This couple began to argue about money, with these fights escalating over time because Colleen felt her return to work was premature. Colleen was furious their financial reality left her without any choice when deciding the timing of her return to work.

It's true that money is a hot topic that causes plenty of stress and arguments in just about any marriage. And more money won't necessarily alleviate fighting about it, because money often represents so much more than just money. Money often represents power and control in relationships, manifested in who decides how much is saved or spent, and on what. But the lion's share of many fights about money revolves around not having enough of it.

In your marriage, your work life, your personal life, contrary to popular belief, in many ways money really *can* buy you happiness. How? Because *money can buy you freedom.* Freedom to choose. Freedom to live the life you want, and freedom as your ticket out of a miserable marriage, relationship, and/or job.

Freedom and Happiness

The freedom of choice that only money can buy provides financial independence, and with that independence comes a sense of empowerment. Financial independence allows you to do *what* you want *when* you want and *with whom* you want (or perhaps by yourself). The feeling of exuberance brought on by financial independence can surely make a huge contribution to your happiness. For working moms, think about the security, peace of mind, and happiness that comes from being able to provide the best childcare money can buy so you don't have to "spend" your time and energy worrying about how your kids are being taking care of while you are at work. Financial independence can allow you to leave a horrible job or an unhappy marriage.

Of course, being rich doesn't automatically make you happy. Believe me, I've worked with many miserably wealthy people on the New England Gold Coast. In some cases, too much money allows you to surround yourself with too many people willing to tell you anything that keeps their gravy train

rolling, even if their so-called *professional* advice leads you towards a train wreck. Or literally costs you your life. We only need to look at some of the celebrities and athletes who fell victim to unscrupulous people who, under the guise of caring for them, really wanted their money: Alex Rodriquez (A-Rod), Justin Bieber, Lindsay Lohan, Michael Jackson, to name only a few. These superstars were, or remain, surrounded by people who did not have their best interests in mind. They were more concerned about milking them for a buck. Other wealthy people, rather than experiencing freedom with their vast financial resources, are enslaved by it because it consumes and dominates their very existence. Given the small percentage of people that accumulate such incredible wealth, these circumstances are by no means the norm and irrelevant for the average women.

The average working woman, the majority of whom are struggling to make ends meet, have little if anything in common financially with the superstar athlete or Hollywood celebrity. We are raising families and working at jobs that exhaust us both emotionally and physically. We are stressed out just trying to put food on the table and clothes on our kids' backs. The price of college is a constant nagging worry.

The chronic stress and worry directly related to lack of money compromises the health of many women. Research shows chronic stress leads to increased cortisol levels, a major contributor to weight gain, irritability, fatigue, and other medical ailments.

For many women, my mom being one, oh how a few extra bucks could have gone a long way to remove stress from their lives. Money to purchase healthy take-out dinner instead of having to come home to five kids and cook a meal after working a ten-hour day (excluding an hour-and-a-half subway commute each way). Or the ability to buy clothes instead of banging away on a Singer sewing machine until two a.m. And don't forget about taking a "real" vacation! Women living paycheck to paycheck will tell you how absolutely terrified they are of losing their jobs, although

they may be working ten- or twelve-hour days in the workplace, then coming home to their second full-time job of taking care of the kids and the house. A little extra time and a lot more money would create plenty of happiness for just about everyone.

Look How Money Bought Happiness for These Lucky Employees!

Have you ever watched the CBS TV show *Undercover Boss*? Every week this popular show has the CEO of a company disguise him or herself as a regular employee who goes "undercover" as a new trainee to be trained by unsuspecting employee(s). Many episodes show the undercover boss struggling with either the pace and physical stamina required of his new position, the frustration of working with rude customers, and/or the lack of support from corporate headquarters via inadequate equipment or ineffective and/or downright stupid corporate policies.

As the training progresses, the undercover boss learns about the personal struggles of his trainers. Some of their hardships are related to inadequate funds for the purchase of quality health care or childcare. Or the ability to buy a reliable car to transport themselves back and forth to work. Whatever the specific circumstance, increased financial resources might not solve the problem, but it would certainly go a long way towards relieving the stress surrounding the problem.

At the end of each episode, the undercover boss calls the employees who trained him or her into corporate headquarters and reveals his true identity as CEO of the company. During these meetings, the undercover boss talks to the trainees about how impressed (or unimpressed) he or she was with the employees performance. The CEO then discusses how he or she was emotionally moved to learn about the employees' personal struggles. Next, in a gesture that totally surprises and shocks the

employees, the CEO graciously provides a gift to these employees to lift their burdens. Sometimes this gift is in the form of actual dollars; other times it's "in-kind" benefits. Upon receiving their gift, it is poignantly clear to all viewers how these unexpected financial resources will dramatically transform the employees' lives and that of their families.

The undercover boss uses money to literally buy happiness for his or her employees by purchasing stress out of their lives, in one form or another. *Ask these employees, and they will resoundingly tell you money just bought them happiness!*

Marriage, Love, and Money

The happier a couple is in their relationship, the more overall happiness they experience in their life. But watch marital happiness and satisfaction go right out the window when the bills can't be paid! The number one reason stated for divorce: money. Since I've spent years working with couples, I can vouch for this. The number one reason stated for marital fights: money. I've witnessed some real doozies over the years!

Your individual relationship with money (and believe me, you have as real a relationship with money as you do with anyone or anything else in your life [we will talk about this more in Chapter Three]), is as vital to your marital happiness as anything else. Why? Because marriage is as much a financial relationship as it is a romantic one. This becomes self-evident when money becomes tight and a marriage dissolves. Ask any divorce attorney, and he will tell you that fighting about financial assets is the third rail in most contentious divorces. As I tell all my clients, *divorce is never about the money, until it is about the money*!

If I were to ask you what keeps you up at night, I bet you eight out of ten times the answer relates to money, and not having enough of it to fix the car, pay the mortgage in a timely manner, put the kids through

college, etc. Having enough money eliminates these specific types of fears while simultaneously increasing your overall sense of well-being as your stress level is diminished.

> *Perhaps the greatest contribution to happiness money makes in our lives is its ability to buy stress out of our lives, resulting in our contented peace of mind!*

If you think money cannot buy you happiness, I urge you to think again. Money can buy you happiness, as long as you don't become consumed by it or a slave to it. You don't need to build a financial empire or own a private jet, although if you want to do that, that's cool. In her book *You Don't Have to be Rich*, Jean Chatzky writes:

> *People who are happier with their finances are more likely to be happy with their jobs, relationships, health, friendships, appearance, self-esteem, children (if they have them), and lifestyle. They are less likely to worry about all of these aspects of their lives. . . And when they do feel stressed (these days, everybody feels stressed sometimes), they are more likely to work those feelings out by doing something positive, like exercising. People who are dissatisfied with their finances are more likely to deal with stress by doing something that's not good for them, eating (more Doritos than broccoli, I'd imagine), smoking, or doing drugs.*

Being brought up to believe the best things in life are free is a fraudulent message. Make no mistake about it, many of life's most enjoyable experiences come with a price tag! Ignoring the hard, cold reality that money does indeed make the world go round leaves many girls unprepared for financial adulthood and many women financially at the mercy of their romantic partners and/or bosses (both of whom are usually men). *Money can buy you happiness in the form of independence,*

enjoyment, comfort, security, and peace of mind. Who in their right mind wouldn't want more of that?

Given the critical role that happiness plays in our lives, why would women (or anyone else for that matter) leave our daughters uneducated about this essential commodity? Why would we allow ourselves to remain in the dark about finances and allow men to dictate the terms under which we have access to money? It just makes no cents! Pun intended!

Annemarie was a stay-at-home mom who never had any interest in her family's financial situation, until her husband left her for a younger woman, taking his considerable wealth with him. Faced with a financial baptism by fire, Annemarie became financially savvy and created a fiscally solvent future for herself and her children once she took off her financial blinders. She learned some basic financial principles of saving and investing. She learned the value of a buck under the most stressful of circumstances.

Amanda Steinberg, founder and CEO of Daily Worth (www. dailyworth.com), began her blog after her husband left her with two young children. By talking to many otherwise smart, sophisticated women, Amanda realized how much women were yearning for financial knowledge and created a blog to fill this void. Today, Daily Worth is the leading digital media for women seeking financial information. It has over one million female subscribers and is considered the "go-to" resource for women seeking knowledge about money as it relates to their personal lives, professional careers, and entrepreneurial endeavors.

Conscious and unconscious attitudes about money, along with the many external barriers discussed above, such as the belief that "love will pay the rent," women's need to be liked (at all costs), and the "good girl" syndrome, whose seeds are sown in childhood and blossom in adulthood, all play significant roles in preventing women from getting paid what they are worth (or charging what they deserve).

Now let's learn how women contribute to keeping the gender wage gap alive and well based upon what we do, and don't do, in our professional careers!

Throughout this book you can go to www.relationshiptoolbox.com/money-book-downloads/ for a variety of important downloadable information.

CHAPTER 2

Making Less Money Than You Deserve? Top Ten Reasons Why Most Women Are Not Paid What They Are Worth & How YOU May Be Part of the Problem!

"No one can make you feel inferior without your consent."
—Eleanor Roosevelt

According to Forbes.com, when given the chance to negotiate their salary, only 7 percent of women take advantage of the opportunity, compared to 57 percent of their male counterpoints.

Will you be one of those women who hesitate to get paid what you deserve?

A fascinating article published on Forbes.com discusses the results of various studies that show the *gender wage gap exists even before women begin collecting their first paycheck.* A study conducted in 2012 asked students what expectations they had for starting salaries. Results showed women anticipated an annual salary of $48,237, while men anticipated an annual salary of approximately $55,000.

Does this create a self-fulfilling prophecy, since total compensation for women upon accepting their first job is often less than what men

are getting paid in a comparable position? In case you think small pay differentials between you and your male counterparts are not really "that big a deal," think again. Is a million dollars a big enough deal to think twice about this issue?

Economist Linda Babcock of Carnegie Mellon University states, "I tell my graduate students that by not negotiating their starting salary at the beginning of their career, they're leaving anywhere between $1 million and $1.5 million on the table in lost earnings over their lifetime." Even a small pay increase often results in larger annual pay raises and bonuses based on a percentage of one's yearly salary.

Along with lower starting salaries as a result of no negotiation, another reason for the gender wage gap is the fact that most women don't negotiate their pay raises throughout their careers. Men, in contrast, are far more likely to initiate salary negotiations without any prompting, beginning with their starting salaries.

Upon seeking a new position following your entry-level job, you are certain to be asked during your new job search, "What is your current salary?" The answer to this question will significantly influence the salary you are offered in your new job by your new employer. Why? Your new salary offer is frequently based upon your previous salary. Therefore, it is easy to see how the wage gap doesn't narrow but actually expands over time. Now you understand why the gender wage gap is actually widening, despite the fact that 2013 marked the fiftieth anniversary of the Equal Pay Act of 1963, championed by President John F. Kennedy.

The bottom line: When a woman allows herself to be paid less than she is worth, given her talents, experience, and other contributions to her company, she is participating (albeit unwittingly) in her own unfair, and unhealthy, work dynamic. This does a disservice not only to herself but her company and other female employees as well. Research shows a happy employee is one who feels valued, fairly compensated, and respected.

Being underpaid contributes to an overall sense of unhappiness about one's work and her employer. This is a lose-lose situation for both the employee and the employer.

Websites such as Glassdoor.com reveal industry standard salary ranges based upon job, title, position, and other variables. This website, along with a proliferation of other published salary benchmarks, makes it increasingly more difficult to hide the salary inequality women experience.

Chances are you are part of the statistical odds that place you in the category of women who are underpaid, or you wouldn't have bought this book in the first place. As it turns out, this problem of not getting paid what you are worth shows up in myriad ways. It really isn't a one- size-fits-all dilemma. Take a good look at this list and highlight or circle or scribble in the margins what screams, "OMG, THAT'S ME!"

Top Ten Reasons Why Most Women Are Not Paid What They Are Worth

Based upon my decades of work and research as an executive coach and relationship expert who has helped hundreds of professional and entrepreneurial women, this is what I have seen over and over again in my clients who share with me on the phone or bring into my office their money madness:

1. "They won't like me anymore."

The Wall Street Journal published an article written by Sue Shellenbarger on March 26, 2014, titled "Why Likeability Matters More at Work," which states: "Likeable people are more apt to get hired, get help at work, get useful information from others and have mistakes forgiven." Perhaps this helps explain Sheryl Sandberg's desire to be liked when she began working at Facebook. In her best-selling book, *Lean In: Women, Work, and the Will to Lead*, Sandberg writes:

Less than six months after I started at Facebook, Mark (Zuckerberg) and I sat down for my first formal review. One of the things he told me was that my desire to be liked by everyone would hold me back. He said, "When you want to change things, you can't please everyone. If you do please everyone, you aren't making progress." Mark was right.

Economist and researcher Linda Babcock from Carnegie Mellon University showed people a video of men and women requesting a salary increase using rehearsed identical scripts. "People liked the man's style and said, 'Yes, pay him more.' But the woman? People found her to be way too aggressive," Babcock says. "She was successful in getting the money, but people did not like her. They thought she was too demanding. And this can have real consequences for a woman's career."

Therefore, although women have legitimate concerns regarding likeability and success at work, women must not allow themselves to be shackled and underpaid. Knowledge is power. Armed with the knowledge that asking for a raise can be a political landmine for women, they can spearhead their request knowing that the manner in which they ask is as important as the actual request itself.

Adelaide was marketing SVP at a Fortune 500 company. She was traveling in business class with her male colleagues when she overheard a conversation about their upcoming job performance review and anticipated salary increases. Adelaide was shocked to learn every one of these men had an annual salary of approximately fifteen percent more than she did, in spite of the fact she was significantly senior to two of the four other executives. Distraught with the discovery of this pay inequity, she immediately called me upon landing. I suggested she first calm down and then get her factual ducks in a row, schedule an appointment with the appropriate

member of the management team or HR executive, and in a very professional manner present her case for a more competitive compensation package. To which Adelaide immediately replied: "Oh no! I can't do that. What if they don't like me anymore?" To which I replied: "It's about them respecting you and paying you what you are worth!" She replied: "Yeah, I know, but . . ." and didn't finish her sentence.

Do you think a man would ever think like this?

2. "I don't want them to think I'm being greedy!"

Since when is getting paid what you deserve considered greedy? And why are you okay with the prospect that you might be considered somewhat of a pushover if you allow yourself to be underpaid and unfairly compensated?

According to a recent study by Salary.com, 55 percent of women felt nervous about negotiating their salaries, compared to 39 percent of men. Unlike men, women often feel either undeserving of a raise or need permission to ask for a raise.

Joan worked in the rough-and-tumble world of hedge fund financing. She was the only female on her team and was highly respected for both her intelligence and dogged determination to figure out complicated and perplexing problems. Year-end bonuses at Joan's firm were a formulaic calculation, and everyone pretty much knew what to expect when bonus time came rolling around. At Joan's performance review, her manager praised her work and presented her with a substantial

bonus award; however, it was five percent below what the formulaic calculation suggested. When I asked Joan how she was going to address this discrepancy, she responded: "Oh, Dr. Patty Ann, I'm not going to say anything! I don't want them to think I'm being greedy. After all, it's not like I'm getting paid peanuts!"

Do you think a man would ever think like this?

3. "What if they say no?"

Culturally, women have been socialized into hearing "no" (of any kind) as a personal rejection. Unlike men, the ability to differentiate between business and personal is extremely difficult for women to cultivate. This adds to the difficulty women have when it comes to separating business from the personal aspects of relationships at work. Men can have a difference of opinion and deny each other's professional requests all day long, then proceed to go out and play a round of golf together, followed by drinks at the bar. Men don't take "no" personally. They don't take it as an indication of not being liked; they see it for what it is—a professional difference of opinion. Women, however, react to "no" in the professional arena as a personal affront and may emotionally confuse a professional difference of opinion with a personal rejection. The consequences for this fear of rejection often leads to a woman's inability to initiate a conversation regarding a pay raise because she doesn't want to hear "no" and the subsequent pain of rejection that will ensue.

Barbara was a well-respected member of her company's digital marketing and sales team. She recently spearheaded a deal that catapulted her company's sales revenue twenty-five percent above

their projected yearly target. Upon closing this lucrative and high-profile deal, Barbara knew the time was right to ask for a raise. Yet she remained hesitant to do so. After pressing her as to why she was not striking while the iron was hot, Barbara finally responded: "What if they say NO?" I almost fell off my chair.

Once I understood the backdrop for her hesitancy, I was able to help Barbara understand that as part of the negotiating process, many requests for a salary increase are initially met with a negative response. I told Barbara if she were to experience this very common initial response, she should respectfully ask why and then listen very carefully to their reasoning. If she could not dissuade them during this initial request with cold, hard facts as to how her recent work added considerable financial value, she should request another compensation review in three months, requesting very specific benchmarks that would result in a favorable response. Rather than taking this "no" as a personal rejection, Barbara needed to view it within an objective professional framework and then develop a strategy that would get her to "yes"—just as she would be more than capable of doing with any business project she was responsible for bringing to fruition.

Do you think a man would ever think like this?

4. "I don't want to come across as being too pushy or aggressive!"

Women worry that asking for more money will damage their image. Unfortunately, research reveals some truth in this concern. Sandberg states in her book:

There is little downside when men negotiate for themselves. People expect men to advocate on their own behalf . . . for men, there is truly no harm in asking. Research has shown it is critical women negotiate correctly for a raise or they will, in fact, be perceived as too pushy and aggressive and hence disliked.

Yes, one may argue this is not fair, but unfortunately, many things in life are not fair.

Arielle was an accountant in a large public accounting firm. Her recent promotion put her squarely on partner track with increased responsibilities and visibility to the top management team. Upon receiving her promotion, she noted the increased time required to successfully perform her new duties and believed the increased raise she received did not sufficiently represent the extra time she would be putting in at work. It took several conversations with Arielle before she agreed to approach Human Resources with what was an insufficient salary increase given her new role and responsibilities. I strategized with Arielle on how to discuss this situation with hard, cold dollar and cents facts that correlated to her new position. The Human Resources professional communicated with the management team and gave her the requested salary increase based upon the facts presented and her business reasoning. Emotions were not a part of the conversation.

Do you think a man would ever think like this?

5. The "Good Girl" Syndrome

Women are generally more reluctant to ask for a raise because we don't want to step "out of line" or do something that would make us feel selfish or demanding. In other words, we will go to great lengths to avoid being considered anything other than the "good girl."

Women often want to help others and make everything easier for everyone. Asking for a raise is a conversation that could potentially become heated and perhaps confrontational, and women prefer to be empathic. When Carol Drew was writing about women and salary negotiation, she said, "Women tend to think of it as demanding."[4]

Psychologytoday.com discusses the double standard where a woman who asks for more of anything in the workplace is often looked down upon, while men who do the same are glorified and seen as ambitious and driven (in a positive way). A female requesting a raise or more responsibility may be perceived as rocking the boat; a male doing the same is often perceived as proactive and adeptly navigating a new course.

Experts on gender and negotiation find discrimination persists in the workplace. It isn't necessarily intentional or overt, but it can emerge when women act in ways that aren't considered sufficiently feminine, such as when women advocate for themselves. Some research shows people find this to be unseemly for women on an unconscious level.

Jessi Smith, a professor at Montana State University conducted a study titled "Women's Bragging Rights: Overcoming Modesty Norms to Facilitate Women's Self Promotion." She discovered a link between "norm violation" and a woman's ability to self-promote: "Engaging in 'norm-violating' activity triggers anxiety, and ultimately poor outcomes. Even in 2014, fear of unladylike bragging stresses women out" in the workforce. [5]

Women asking for a raise violate the "good girl" social norm that women shouldn't ask for anything. Smith's research shows people do not react positively when a female gives her opinion, speaks out, or promotes herself and/or her work, reinforcing the difficulty women have with salary negotiations or raising their hand to start a new business initiative. It is

4 http://slchamber.com/blog/tag/woman

5 http://www.huffingtonpost.com/2014/01/22/modesty-norm-womoen_n_4644151. html?goback=%2Egde_2138864_member_5835016484341

much safer for women to just go along for the ride by staying true to their "good girl" image rather than rocking the boat.[6]

Do you think a man would ever think like this?

6. "I will just wait until they offer me a raise!"

The cliché "Opportunities are rarely offered; they are seized" could not be truer when it comes to business in general and asking for a raise specifically. Timing is almost everything in life, and waiting for things to happen usually leaves you waiting for Godot, especially for women in business! Women "wait to be offered a salary increase . . . they wait to be offered a promotion. They wait to be assigned the task or team or job that they want. And those things typically don't happen very often," according to Linda Babcock.[7]

Isabelle received a promotion and, with it, a negligible salary increase, although her new role and responsibilities increased her travel time by 60 percent. When I suggested she promptly negotiate a higher executive package, she told me she didn't want to rock the boat. She felt she had a good thing going (remnants of the "good girl" syndrome at play here) and was afraid they would rescind the promotion (which I told her I highly doubted!). After much cajoling, Isabelle requested a review of her executive package and received a fifteen percent salary increase with added bonus structures and increased stock options. Getting Isabelle to initiate this discussion was like asking her for her right arm.

6 http://www.huffingtonpost.com/2014/01/22/modesty-norm-women

7 http://blogs.wsj.com/atwork/2013/05/30/you-wont-get-a-raise-if-you-don't-ask-for-one/

For the past two years Annabelle received excellent performance reviews. Her work was described as exceeding expectations, and she was consistently praised as someone who could adeptly find a way to smooth ruffled feathers with both her superiors and team members. She was described as the "go-to" person who could get difficult assignments done in a timely and efficient manner. She was often referred to as the "calm in the eye of the storm," especially when it came to unanticipated crises. Following her past three reviews, Annabelle was told her work exceeded the highest of expectations, but unfortunately, the budget lacked funds to give her a raise. I told Annabelle that almost every company could find a way to access more compensation for retaining valuable employees. Annabelle refused my advice to ask management in a politically correct manner to find creative ways to increase her compensation. Rather, Annabelle insisted she would wait until the company created a budget that would support her long overdue raise. In the end, Annabelle and the company lost out because, big surprise, the company never offered her a raise. She subsequently left the company for a lateral position with equal pay in another organization.

Do you think a man would ever think like this?

7. Erroneously Believing My Excellent Work Will Automatically Get Noticed

"We're raised as women to believe you'll get what you deserve if you keep your head down," says Chloe Drew, executive director of the Council of Urban Professionals. "Many women who don't ask for promotions never get them. They wait, thinking that their boss will hand them a raise and/or more responsibility, but often get passed over in favor of someone less qualified because the other person stuck a foot in the door."

The expression "Good things come to those who wait" does not ring true in business. Women usually wait until the designated annual review to ask for increased compensation, lest they are viewed as demanding and unappreciative.

Barbara worked in the advertising industry and ran the most successful ad campaign in the history of the company. She believed her excellent work performance warranted a raise in total compensation. Rather than approaching her superiors on the heels of her successful campaign, Barbara thought it would be more prudent to wait for her performance review, which was five months away. The problem with this strategy was that Barbara's immediate supervisor left the company two months prior to her review. The executive who replaced him had minimal knowledge of Barbara's spearheading role in the company's highly successful ad campaign. He was ignorant of the fact that Barbara did most of the heavy lifting to make this campaign the raging success it was. Therefore, although Barbara received a salary increase, one can easily speculate that it was significantly less than what she would have received had she approached her previous supervisor in a more timely and strategic manner, especially since most businesses operate under the premise of: "What have you done for me lately ("lately" being "five minutes ago")?"

Do you think a man would ever think like this?

8. "I would love more money, but I'm not sure my work/position is worth it!"

Women shy away from salary negotiations, in part due to low self-esteem: "They do not feel sufficiently worthy or entitled to ask for

something, whether it be a pay raise, a promotion, or even the time and attention of a superior," according to Christina Bombelli.[8]

An article written in *The New Yorker* by Ken Auletta discusses how women defend themselves against being disliked by playing down our accomplishments, having *hesitancy to take credit for our work in the workplace, and doubting our abilities,* thereby taking ourselves out of the game before anyone else does. Many women undervalue their own work and are following gender-based rules about not being allowed to speak up for fear of being rejected.

This will not be the last time you hear me say this: I have *never*, and I emphasize the word *never*, heard a man say (or believe) he is overpaid. And yet, we all know plenty of men who are! According to Forbes.com, women are less likely to negotiate higher salaries and compensation for ourselves because we tend to have lower expectations than men when it comes to the salaries we believe we deserve.

Susan was an EVP of a rapidly growing Fortune 100 company in Connecticut. Her job responsibilities included strategic development for new business initiatives. Her position required overseas travel 30 percent of the time, and she often toiled away at home well into the evening when she was not on the road. While traveling on a business trip with a male colleague, the conversation turned to compensation and benefits for the new senior employees who were being acquired by Susan's company. Susan's male traveling companions casually threw out a compensation range, which at its lowest end was $50,000 above Susan's salary. When Susan suggested that the number was a little high, her male colleagues stated, "Look, Susan, it's not as if they will be getting paid more than we are!" To which Susan just smiled and replied, "Yeah, I guess so." Although Susan was beyond outraged

8 http://www.europeanpwn.net/index.php?article_id=70

> with this information, she never pursued a conversation
> about this salary discrepancy with anyone in her company,
> preferring to fume in silence at its injustice. When I asked
> her why she was ignoring this pay inequity, she very timidly
> replied, "You know, maybe my work isn't really worth it!"

Do you think a man would ever think like this?

9. "I'm not any good at negotiating for more money!"

The interesting thing about this stated reason is that it is not true. Women tend to be excellent negotiators, for everyone but themselves. The dilemma for women is they view their own salary negotiation as entering into conflict, and many women tend to avoid conflict (especially surrounding themselves) at all costs. Women need to reframe their view around self-negotiation as having a business conversation around money and not about entering into an argument. If you must, take the personal aspect out of your money negotiation by pretending you are advocating for someone other than yourself, perhaps a member of your team whom you know unequivocally deserves a pay raise.

Remember this: You are in business to make money, not only for your company but for yourself as well. *It is as much your fiduciary responsibility to earn the money you deserve for yourself (and your family) as it is for you to increase the bottom line for your company.* These goals are not mutually exclusive, and women should not view them as such.

> *Jill was a vice president working for a consumer product company.*
> *She had a reputation for being a fierce advocate for her subordinates*
> *when it came to negotiating salaries bonuses and professional*

advancement. What Jill's colleagues didn't know was that she hardly ever negotiated her own compensation, often just accepting what was offered to her. When questioned about her meager attempts to negotiate for herself, Jill replied, "I know. I'm great at negotiating for everyone other than myself." The truth was not that she wasn't good at negotiating for herself, as much as she just never did it!

Do you think a man would ever think like this?

And the tenth reason why women don't make more money and get paid what they are worth is:

10. Women Just Don't Ask!

The bottom line for women not getting paid what they are worth is simply based on the fact that women just don't ask for it! All the reasons listed above illustrate valid external and internal obstacles women face, but in the final analysis, *women just don't ask for more money, so they don't get it.* Fear of being disliked, fear of being told "no," fear of not being the "good girl," fear of being seen as too aggressive or too greedy, fear of negotiation, low self-esteem, undervaluing their own worth and work, the tendency to inappropriately wait for a raise to be offered, etc., are all variables preventing women from getting paid what they are worth. These reasons keep women silent when they should be speaking up. Silence has rarely spearheaded change.

A special report conducted exclusively by McKinsey & Company for the *Wall Street Journal* Executive Task Force for Women in the Economy, published on April 30, 2012, titled "Unlocking the Full Potential of Women at Work" by Joanna Barsh and Lareina Yee, reports the finding

of a male CEO who said, "Women don't knock on my door the way men do, or ask for advice. I wish they were more proactive."

In other words, women just don't ask.

Requesting more pay is not the only thing women have difficulty asking for. Women have difficulty raising their hands to ask for more opportunities and responsibilities. Women also find it hard to ask for or seek out sponsors who can give them access to the managerial decision-makers (perhaps another manifestation of our fear of being seen as too aggressive or ambitious). Linda Babcock, a professor of economics at Carnegie Mellon University, addressed this issue by asking why so many male graduate students were teaching their own courses while their female counterparts were just teaching assistants. Babcock was answered with: "More men ask. The women just don't ask."

Do you think a man would ever think like this?

Go to http://relationshiptoolbox.com/money-book/ten_reasons_women_not_paid_what_they_are_worth.pdf if you would like a copy "The Top Ten Reasons Why Most Women Are Not Paid What They Are Worth."

The bottom line: If you don't ask for what you want in life, you are practically guaranteed not to get it. It is really that simple. I'm not minimizing or sugarcoating the fact there are many external barriers that prevent women from getting paid what they are worth. But women must not throw up their hands and surrender. We can change our own individual situation, and for that, we must take individual responsibility. Rome wasn't built in a day, and change starts with each individual.

Now, let's move on and help you increase YOUR bottom line!

CHAPTER 3

Change Your Mind, Change Your Money: Harness the Power of Your Brain & Increase Your Will to Earn!

"I always knew I was going to be rich.
I don't think I ever doubted it for a minute."

—Warren Buffett

Training Your Brain to Increase Your Bank Account

Current neuroscience research and positive psychology show the scientific correlation between our mindset, i.e., what we think and believe to be true in our minds, and the reality we create in our lives. Based upon what we know from sophisticated brain wave patterning and imagery, we can influence, if not create, our reality based upon what we think. Succinctly, what you think is, in fact, what you create!

Therefore, *when you change the way you think, you change your reality.*

Winning begins with the simple belief that you can, in fact, win. Athletes and champions understand the incredible power of the mind. You've heard the expression "the will to win"? This refers to the state of mind the athlete creates long before the competition ever begins. Prior

to the blow of the game whistle, the athlete creates the belief in their mind (mindset) that they will win. Once the athlete sets their mind on winning, practice, commitment, hard work, and determination follow to bring victory to fruition. But make no mistake about it, success begins in the mind.

A winning mindset is the prerequisite for success, not only in sports but in all endeavors we undertake in life—business, music, art, etc. It is also a prerequisite for financial success and wealth accumulation. Women must create a winning financial mindset that sets the tone for creating wealth and financial security by actually believing we can! So how do you go about creating this mindset? It begins the same way everything else we create in our lives begins—in our minds. We must create a shift in how we think about money in our minds.

Mindset

The only true way we can change ourselves is by changing our mindset.

Gandhi said, "We must be the change we want to see in the world." Therefore, if we want to change anything in our life, the first step begins with taking a long, hard look in the mirror. We must first change ourselves.

From our earlier chapters, you know how money *can* indeed buy you happiness. You hold a deeper understanding of the negative consequences of financial ignorance. Now it's time to explore fundamental steps every woman must take to make money and wealth accumulation a reality, one that is as sexy and irresistible as a hot pair of Jimmy Choo shoes. These first steps begin by changing a woman's mindset about money.

You hear the word *mindset* thrown around all the time, but what exactly is it? And how do you go about changing it? Carol Dweck, the brilliant Stanford psychologist who pioneered this concept in her best-selling book *Mindset: The New Psychology of Success*, describes mindset as

"a simple belief about yourself or something (that) can guide, and in fact, permeate every part of your life."

Fixed Mindset vs. Growth Mindset

"Mindsets are just beliefs. They're powerful beliefs, but they are something in your mind, and you can change your mind."[9]

Dweck describes two types of mindsets: a fixed mindset, and a growth mindset. A fixed mindset is predicated upon the belief that one's innate traits and abilities, such as intelligence, athleticism, musical ability, etc., are constant or fixed traits. People who believe in a fixed mindset believe innate talents and abilities cannot be improved upon, i.e., they are fixed. The expression "You either have it or you don't" is indicative of a fixed mindset—a "natural" athlete, a "gifted" musician, and a "talented" writer. Pure talent is the key to success in a fixed mindset (rather than other attributes such as determination and hard work). Therefore, people can only be as successful as their natural ability will dictate.

Those with a fixed mindset avoid challenges because they may lead to failure, with failure seen as an indication of one's abilities. Consequently, people with a fixed mindset only pursue activities that leave them unchallenged, limiting their growth in any activity or skill that doesn't come "naturally" to them.

For example, your fixed mindset tells you that you are not a good science student but an excellent writer. Therefore, you only take writing classes and avoid taking science classes. The writing classes reinforce your good writing skills, while the avoidance of science classes prevents you from expanding your knowledge base. It also prevents you from struggling

9 Dweck, p.16.

with an uncomfortable subject matter. Consequently, you eliminate your ability to improve on anything you are not "innately" good at, limiting your growth and potential.

Since a fixed mindset believes success is based solely upon innate qualities, how then does one account for all those people who are naturally "gifted" and/or "brilliant" and yet fail to achieve and live up to the potential their innate attributes suggest they have? Perhaps other variables are at play for success?

In today's highly competitive modern world, we know that innate intelligence and talent alone is not enough to succeed. Success requires a growth mindset. A person with a growth mindset tells herself that she "can" and "will" achieve her goal. This positive attitude defines her mindset and influences her behavior, regardless of the obstacles and circumstances she might encounter. This attitude and belief is at the heart of every winner and anyone who has ever achieved greatness.

At the heart of a growth mindset is a relentless quest to learn and grow via dogged determination, passion, perseverance, and practice, intermingled with self-confidence in one's ability to succeed in the face of adversity and failure, often repeated failure. *People with a growth mindset continuously believe they can get better at what they do, regardless of how many times they experience failure.*

People with a growth mindset believe talent and ability can be improved upon. They embrace challenges and risk-taking activities that may result in failure. Failure is not seen as an indication of one's ability or as a dead end in pursuit of one's advancement and improvement. Rather, failure is seen as an opportunity to learn, grow, and expand one's realm of knowledge (as opposed to the fixed mindset that avoids risk-taking activities in order to avoid failure).

Derek Jeter, the beloved captain of the New York Yankees, retired at the end of the 2014 baseball season following a spectacular twenty-year

career in pinstripes. When Jeter's coaches from Little League on up were asked about his athleticism, every single one stated he was not the most talented player they ever saw, but he thought he was. Combined with an amazing work ethic of consistency, practice, determination, and an unquenchable desire to be the best, he did, in fact, become the best! Other players possessed more natural talent, but it was Jeter's growth mindset that set him apart, eventually putting him in a league of his own!

Mia Hamm, perhaps the greatest female soccer player of all time, is often asked about the most important thing for a soccer player to have. Without hesitation Hamm has repeatedly answered this question with two words: "mental toughness." Hamm states, "It is one of the most difficult aspects of soccer, and the one I struggle with every game and every practice."

The mental toughness Hamm is referencing is not an innate (or fixed) trait; rather, it is acquired, a learned skill. A skill nurtured and developed during game situations when eleven members of the opposing team want to take you down; when you are physically hurt, injured, or exhausted; when the calls are going against you. Hamm states these are the times and situations when you must not allow harsh realities to distract you from your focus, determination, and will to win. Hamm is describing a growth mindset formulated in an insatiable athlete's winning mindset, cultivating the will to win at all costs, whether the odds and the calls are for or against you!

Carol Dweck states, "We like to think of our champions as idols rather then as relatively ordinary people who made themselves extraordinary."

A growth mindset explains why success does not exclude people who appear to be quite ordinary, average, or unremarkable in their youth, yet grow up to become exceptional. It is evidenced when we look at Tolstoy and Darwin, both of whom were viewed as average children. Or Thomas Edison, inventor of the light bulb, known to have struggled with science

as a young student. Consider Michael Jordan, who won six basketball world championships with the Chicago Bulls and yet was cut from his JV high school basketball team. Oprah Winfrey was fired from her original job as a street reporter on Baltimore Maryland's WJZ-TV, being told she was unprofessional because she couldn't keep her emotions out of her reporting. After finally getting signed by a major record label, Lady Gaga was dropped after three months. At the start of her career, Marilyn Monroe was told by a modeling agency she might consider becoming a secretary. Lucille Ball was considered a failed, B-List actress and told by her drama teachers to consider another profession before she became the star of the iconic *I Love Lucy* TV series.

Consider also Sir Richard Branson, entrepreneur extraordinaire, founder and chairman of Virgin Group, who suffered from severe dyslexia as a child, as did President George Washington, Leonardo da Vinci, Albert Einstein, Jay Leno, and Keanu Reeves.

Given the above successes, it becomes quite clear that a growth mindset, rather than a fixed mindset, is the incubator for success. We all know people whose lackluster careers belie their high IQs, or the natural athletes or gifted musicians who fail to practice their skill, leaving their potential unfulfilled. The competition displayed in sports on all levels consistently demonstrates the power of the growth mindset. It explains how the underdog can become a stunning success. It allows us to understand how David can beat Goliath, in every arena of life!

Failure as a Prerequisite for Success

Failure is success if we learn from it."
—Malcolm Forbes

Earlier we talked about the vital role failure plays in the growth mindset. As a matter of fact, to be successful in life, it is mandatory that you fail. Why? Because we learn so much more about ourselves from our failures than we will ever learn through our successes. Failure acts as a laser focused on the areas in our life that need improvement.

Failure is at the heart of the growth mindset. Overcoming failure requires perseverance and determination, often in the face of adversity. Once overcome, failure builds self-confidence and increases self-esteem, providing the foundation to take one outside one's comfort zone to seek new risks and challenges that, once again, provide new opportunities for growth.

The indomitable pursuit of success can only be achieved if adversity and failure can be met and overcome, as opposed to having it stop you dead in your tracks. Most great achievements have been preceded by countless failures, with these achievements the result of having the ability, confidence, and growth mindset to face failure head-on to ask: "Where did I go wrong?" or, "What do I need to do differently?" or, "How can I improve this next time?" instead of making excuses. This "can-do" attitude is tantamount to a growth mindset that yearns to expand one's knowledge and push the limits. Success makes us feel great, but it does very little to improve our skill set or knowledge base, whereas failure, if we let it, is our greatest teacher.

Yesterday's helicopter parents are characterized as being over-controlling, over-protecting, and over-perfecting. Helicopter parents pick their kids' teachers, coaches, peers, and even their friends. In some circles, today's "snowplow" parents have replaced helicopter parents. Snowplow parents move ahead of their children in an attempt to clear all obstacles and roadblocks out of their children's way on the path to success. These two parenting styles do children a tremendous disservice, because they provide them with nothing less than a hollow victory. Why? These children

have never been afforded the opportunity to misstep, stumble, and fail. They've missed out on an incredibly important childhood developmental milestone, one that is the prerequisite for frustration tolerance and the precursor for effectively handling adult failure. In other words, *the mandatory failure that is the prerequisite for true success is absent.* When these kids claim success, it is analogous to me stealing a championship trophy and claiming I am a champion (a little bit of a stretch, but you get my point).

Parents would do well to encourage their children to take risks and explore new opportunities rather than encourage activity that reinforces their strengths. These new and perhaps difficult activities will expand and grow the child's mind and development. They will give them the opportunity to fail at a time when failure offers very little real-world consequences while simultaneously offering the child many real-life valuable lessons. Knowing your vulnerabilities is much more valuable to one's growth than reinforcing one's existing strengths.

Remember, absolutely no one has ever achieved anything great in life without failing miserably first!

Changing Your Money Mindset

"Those who say they can and those who say they can't are both usually right."

—Abraham Lincoln

Gumby, Brain Plasticity, & Rewiring of the Brain

Our brain is not static; it is malleable. It changes in many ways, biochemically, structurally, and functionally, throughout our lifetime. Neuroscientists refer to this quality of the brain as neuroplasticity or

brain plasticity. *The properties of neuroplasticity allow the brain to constantly rewire itself throughout our lives.*

Shape & Bend Your Brain Like Gumby

To visualize the plasticity of the brain, it might help to think of our childhood toy Gumby, the plastic green man that could bend and change its shape based upon how you twisted and moved its body parts. In a similar fashion, the brain too can be reshaped based upon how you twist and move it via learning and experiences. Just like a muscle, you can expand and strengthen certain areas of your brain, thereby improving the specific functions associated with its specific areas. Conversely, your brain can weaken and deteriorate, resulting in a proportionate loss of function and ability. Think of your brain as a muscle: If you use it, it strengthens; if you don't use it, it weakens.

The shape of anything determines its ability to function—this is as true for the brain as it is for anything else. Brain plasticity involves and allows for a dynamic physical process. The brain's gray matter collapses (shrinks) or expands (thickens), thereby changing the neural connections made and the neural pathways traveled. Neural connections can be enhanced, severed, refined, weakened, or created. All these changes in the anatomy of the brain (many of which can be detected with neurological brain imagining tests) result in functional changes for the brain.

The following are two examples of how your brain function changes based upon *what it is or is not exposed to*. Your fluency to speak a foreign language becomes enhanced based upon how often you expose your brain to that language, in both verbal and written areas. The more often you speak and read the language, the more your verbal and written fluency increases. Your fluency with the foreign language will decrease with less exposure to it, because the area of your brain responsible for language

development becomes inactive. Again, the analogy of your brain to a muscle is relevant here, exercise strengthens it, and lack of exercise weakens it (an oversimplification, but it works nonetheless).

Another example of brain plasticity appeared in an online article in Positscience.com:

> *Each time we learn a new dance step, it reflects a change in our physical brains: new "wires" (neural pathways) that give instructions to our bodies on how to perform the step. Each time we forget someone's name, it also reflects brain change, "wires" that once connected to the memory have been degraded, or even severed. As these examples show, changes in the brain can result in improved skills (a new dance step) or a weakening of skills (forgotten name).*[10]

Rewiring Our Money Mindset

"Mindset is so powerful that it affects the way we act, feel, make decisions and ultimately our life."
—Carol Dweck

As mentioned in Chapter One, one of the main reasons women do not earn what they deserve or possess more financial knowledge is related to the way women are raised and culturally influenced about money from the time they were little girls. The very first thing women must do to take financial responsibility for their lives is to change their negative money mindset into a positive money mindset. Experiences, learning, and beliefs

10 http://www.positscience.com/brain-resources/brain-plasticity/what-is-brain-plasticity

play a major role in influencing how we (re)wire our brain patterns. As Gumby can be manipulated to change his shape, our brain can be manipulated to change its neural patterns. Neuroplasticity provides the scientific validity for how the exercises below will, indeed, change your money mindset.

Let's begin to change our money mindset by engaging in the exercises below that will create a Money Mindset Makeover. The four simple exercises below will help rewire your brain to create a positive money mindset. (Do not underestimate the power of simplicity.)

EXERCISE I
Determine Your Current Money Mindset

Determine your current money mindset by writing down your answer to the following questions:

1. ***Identify your attitude*** about money by writing down a sentence or two that describes how you feel about money.

 For example: "Money is the root of all evil"

 or "Money provides the means to enjoy life"

2. **Where** did your first impression(s) about money (that you wrote in the above exercise) come from?

3. ***Who else influenced*** your initial views and feelings about money by reinforcing them? How?

4. What *experiences* influenced your initial views and feelings about money by reinforcing them? How?

Review your answers upon completing the above exercise(s) to discover the state of your current money mindset, and who and what influenced it.

If the above review reveals you have a positive mindset about money, that's fantastic! Do the exercises below to reinforce your positive money mindset and keep it strong. If your review reveals you have a negative money mindset, let's begin to transform your mindset from negative to positive by doing the activities below.

Affirm the Change You Want to See

Russ Harris states in his book, *The Happiness Trap*, that over 80 percent of our thoughts are negative. This creates an overall negative mindset. We can shift these negative thoughts to positive ones and, in so doing, transform our self-limiting and destructive mindset to a positive one. *Affirmations are the catalyst for this mindset change.*

What are affirmations?

Affirmations are short, powerful statements that help re-program (or rewire) your brain. When positive affirmations are repeatedly said to oneself with conviction and authenticity, they shift your internal negative thoughts to positive thoughts by re-wiring your neural brain pathways and hence your mindset. *Creating a positive mindset will profoundly change your life. Remember what we learned earlier in this book: If we think it, we can create it!*

EXERCISE II
Create a Positive Money Affirmation

1. Create a positive affirmation regarding your attitude and view about money.

Write this positive affirmation down and put it in an obvious place where you will see it daily.

For example: "I am a Money Magnet!"

"I have the Midas Touch!"

"Everything I touch turns to gold!"

1. *Write your positive money affirmation here:*

2. *Repeat the above positive money affirmation you created three times a day: morning, afternoon, and evening.* It would be ideal if you could say these affirmations out loud. Why? The spoken word has an incredibly strong effect on your brain. If the pen is mightier than the sword, then the spoken word is mightier than the pen. Think of how inspired you become when you hear an impassioned speech, as opposed to how you feel when you silently read this same speech. If speaking your affirmation out loud is not possible, then go ahead and repeat the affirmation silently to yourself, this will also get the job done. How? Positive money affirmations re-wire your brain's attitude about money and begin shifting your money mindset from the negative to the positive.

Go to relationshiptoolbox.com/money-book/examples positive money affirmations.pdf if you would like a copy of "Twenty-Five Examples of Positive Money Affirmations."

Congratulations! Upon completing the exercises above, you are well on your way to creating the shift from a negative money mindset to a positive one. This mindset shift is critical to your overall happiness; it will provide you with the proper beliefs and attitudes needed to make sure you get paid what you are worth. This mindset will help you accumulate wealth and financial security. Having the choices only money can buy will reduce stress in your life, increasing your happiness and overall well-being.

Remember: If you think it, you can create it!

CHAPTER 4

Seven Sure-Fire Tools & Strategies to Negotiate Your Worth

"Let us never negotiate out of fear. But let us never fear to negotiate."

—John F. Kennedy

We would be naïve to think men and women are treated equally in the workforce. Perhaps nowhere does this inequality appear more than in how men and women are perceived when negotiating salaries and other perks. Since I'm a very practical person, this chapter is not about telling you how unfair it is that women are underpaid for work that is comparable to a man's. It's about providing practical, do-able information on how to negotiate getting paid what you are worth, while working within the system as it exists today. I will leave the policy changes to the Sheryl Sandbergs and Mika Brzezinskis of the world!

At this point we know women are more unlikely to negotiate their salaries than men, beginning with one's initial salary offer immediately out of school. Like it or not, fair or unfair, women must tread the same salary negotiation waters differently from men.

On October 9, 2014, Microsoft's CEO Satya Nadella was speaking at the Grace Hopper Celebration of Women in Computing when he was asked how women should go about asking for a raise. Nadella replied, "It's not really about asking for a raise, but knowing and having faith that the system will give you the right raise. That might be one of the initial 'super powers' that, quite frankly, women who don't ask for a raise have."

The fallout from this ridiculous comment continues. However, I highly doubt Nadella would have kept his CEO job had he given the same response to this question in response to how a man should ask for a raise. Shareholders, employees, and customers alike would have speculated about the status of Nadella's mental health.

On a closer look, Nadella's comment reveals the unconscious bias in how men and women are viewed in the workforce, not only as it relates to salary negotiation, but in other areas as well. Society has conditioned men and women to think differently about money. The fact that men and women, albeit unconsciously, negotiate differently (or not at all) is based upon the societal messages discussed earlier in this book. Succinctly, men are expected to aggressively seek out higher compensation, whereas women are often frowned upon when doing the same. This discrepancy ignores the fact that men and women are both working, in the final analysis, for monetary gain. Suggesting otherwise is disingenuous, even if women themselves often fail to publicly and privately acknowledge this reality.

Differences between How Women and Men Negotiate

According to a recent study by Salary.com, 55 percent of women felt nervous about negotiating their salaries, compared to 39 percent of men. Following are some of the findings women themselves have put forth accounting for this difference. Women feel as if they need permission

to ask for a raise. Women are not confident in their negotiating skills. Women often feel undeserving of a raise. Men tend to put themselves into negotiating positions, whereas many women tend to either avoid or remove themselves from these positions. Women tend to undervalue their worth in ways inconceivable for most men. (For a more extensive description of why women have difficulty asking for a raise, please see Chapter Two in this book.)

A study by *Harvard Business Review* revealed that when men and women do negotiate, men tend to negotiate twice as often as women. When men were asked when their most recent negotiation was, they responded, "Within roughly the past two weeks," while women responded to the same question by answering, "Within roughly the past four weeks." Furthermore, when it came to future negotiations, women predicted they would enter into them in approximately four weeks, while men responded by answering within only one week.[11]

While negotiating, men tend to be more aggressive. They utilize the competitive skills they learned in childhood and carry them forth into the workforce, resulting in a winner-take-all mentality. Conversely, women are generally more reluctant to ask for a raise because they don't want to be seen as competitive, stepping "out of line," or risking behavior that might be interpreted as selfish, demanding, or not being a team player.

Unfortunately, women have reason to pause before asking for a raise. Research has consistently validated that women who ask for more or demand more within the workplace are often looked down upon, while men who do the same are applauded.[12] This double standard must cease if we want to end the gender wage gap. We must allow more women to come forward with confidence to advocate for more responsibility, to gain access to the decision-makers, and to negotiate what they deserve to be paid.

11 hbr.org

12 psychologytoday.com.

While being cognizant of all the pitfalls and dangers previously discussed in this book, women must remember that "Forewarned is forearmed." Let's now move forward with a clear negotiation strategy that works for both sexes.

Following are seven tested, proven, and powerful ways women can negotiate their worth, while maintaining their authenticity.

Influential Strategies to Get Paid What You Are Worth

1. Know Your Worth in Very Specific Terms

Know what you should be paid for the work you are doing, where you are doing it, and for whom. For a successful salary and benefits negotiation, it is imperative you do your research and due diligence.

This might seem like a common-sense statement, but you would be surprised to learn how many women have no clue where their current salary falls on the benchmark established for their job description and industry. All that is required to gain this information is a little bit of research. Let's begin with our tried-and-true friend Google. There are myriad websites that have done a lot of the heavy lifting for you, i.e., listing salaries based on occupation, industry, geographical area, etc. Below are some of the websites you may use to research the established benchmarks for your position in no particular order. Undoubtedly there are many more online resources to peruse, so do not consider this list to be exhaustive by any means. By the time this book is published, many websites will have been added and others deleted.

Glassdoor.com (http://www.glassdoor.com/index.htm) offers a "growing database of 6 million company reviews, CEO approval ratings, salary reports, interview reviews and questions, benefits reviews, office photos and more." Glassdoor.com was started in 2007 by Robert Hohman, Rich Barton, and Tim Besse. It is headquartered in Sausalito, California. This

site can be accessed via mobile app on iOS and Android platforms. What differentiates glassdoor.com from other sites is the information provided—it is transparent to both the company and employee, and all the available information is shared by those who know the company best, its employees. Therefore, besides offering invaluable information about benchmarking your salary to your job description, it provides an accurate assessment of the overall corporate culture of the company you may be researching.

Payscale.com (www.payscale.com), or PayScale, Inc., was created by Joe Giordano, formerly of Microsoft, and John Gaffney, a former manager from drugstore.com, on January 1, 2002. Payscale.com was acquired by Warburg Pincus on April 24, 2014 and is headquartered in Seattle, Washington. It is an online salary, compensation, and benefits information company. It is considered to be the creator of the largest database of individual compensation profiles throughout the world. Utilizing online tools and software, it provides current market salaries to employers and employees alike.

Salary.com is one of the most frequently visited salary-specific job sites, offering a vast array of salary information. Roll over the green navigation bar on the top left-hand corner labeled "Salary," and a drop box will appear with a list of invaluable resources to click on and review. Included under this drop box are categories listing information regarding negotiation tips, benefits, hiring trends, and advise for getting hired, to name a few.

An invaluable site that links up to over 300 different sites maintaining a current and up-to-date salary list is found at http://jobstar.org/tools/salary/index.cfm. This site is considered to be one of the most comprehensive and exhaustive lists of salary reviews. It is consistently updated by Mary Ellen Mort and is a gem not to be missed when preparing for your salary negotiation.

Go to www.salaryexpert.com for another invaluable salary information site. This site has differentiated itself by including a free report titled "Salary Report," offering salary information related to job titles organized by geographical location, experience and skill level. SalaryExpert.com was founded in 2000 with the goal of providing not only salary information but an associated cost of living expense report compiled from compensation professionals.

Two government websites, www.bls.gov/ooh and www.bls.gov/oes/oes_emp.htm, are published by the Bureau of Labor of Statistics. The former site provides a survey of salaries for individual jobs, ranking jobs according to the highest paid, fasting growing, and those having the largest number of positions available. The latter site lists salaries in individual industries as published by the Bureau of Labor Statistics. The information from both sites is published in the *Occupational Outlook Handbook.*

On a slightly divergent yet related path, if you are seeking an honest discussion regarding college major(s) and expected salary associated with that major, check out MyPlan.com. This site provides a plethora of information necessary for making informed and practical decisions that help you formulate a correlation between choice of study and anticipated salary. Parents of every college student might want to check out MyPlan.com before plunking down $50,000 plus per year in private college tuition for their child to study a major that does not offer a common sense return on their investment.

Although an abundance of information for researching your job worth is available online, Victoria Pynchon, owner of She Negotiates (www.shenegotiates.com) advises you to do some old-school research by picking up the phone to call a man (or a few men) who is working in a comparable position you are researching. Or have someone you trust make the call and inquire about his current salary. Ms. Pynchon says she doesn't call women because, as is often the situation (based upon statistics

and her own work helping women negotiate their salaries), women tend to be underpaid. Interestingly, Pynchon states a man has never refused her request to tell her his salary. This salary information straight from the horse's mouth, if you will, may prove to be invaluable in many unforeseen ways during your negotiation process.

Remember—knowledge is power! You cannot have enough knowledge in your toolbox when preparing for your salary negotiation meeting.

2. Re-Write Your Job Description (with a "Value Add" Line Item)

Once you know your job worth (within a specific numerical range, which we will discuss later in this chapter) based upon your research, re-write your current job description. Chances are you've added more responsibilities and roles than those you were initially hired to perform or since your last review. To the best of your ability, *add a line item that quantifies your "value add" as it relates to these duties.* Be as specific and as clear and concise as possible when connecting the dots between your job performance and its quantitative added value to the company (and your industry). Additionally, include a section on your resume that reflects your specific productivity and any gained institutional knowledge so it very clearly reflects your market value (to both your company and your industry). This may include any additional formal education you have received, workshops/seminars you attended which have taught you innovative and cutting-edge strategies and techniques that improved your department's bottom line, etc.

Do not assume your manager knows any of this information. It is your responsibility to bring it to his/her attention during your salary negotiation meeting with that ever-critical "value add" number assigned to it. Business operates under the premise of "What have you done for me lately, specifically in the last five minutes?" *Quantifying your past work,*

while specifically demonstrating how your future work will add financial value to the company, sets you up for negotiating from a position of strength, based upon your specific resume!

Yes, successful negotiation is predicated upon establishing and maintaining a healthy relationship with the negotiator, but hard, cold data that quantifies your "value add" in specific dollars (the more specific the better) will exponentially increase your chances for a successful salary negotiation. These "value add" numbers will also help (re)position you for gaining access to the decision-makers who are invaluable for catapulting you up the food chain.

Karen Ewing, senior marketing director of North America for Orion Health, a New Zealand-based software company, states:

> *The key here is to be as specific as possible. Vague statements simply aren't convincing. . . . The easiest way to obtain a salary increase is to show you've had a positive impact on business operations or that your workload has significantly increased to warrant more compensation. . . . I've asked for a raise but only after developing a business case. I showed the facts of the situation of my job, provided specifics on how the position has changed and my scope has increased. My raise was about a return on their investment in my skills.*

A 34-year-old mid-level manager with a well-known marketing company based out of New York strategically initiated her request for a salary increase with her boss three months prior to the meeting. She began by scheduling a meeting with her boss, then created a new resume which itemized a "checklist" outlining her accomplishments in a simple chart, correlating her accomplished goals and its "value add" to the company. The boss was impressed with both the facts

and her confident and self-assured presentation and offered her a higher raise than she thought she would receive. Six months following her raise, her boss offered her the chance for a leadership position in a new division being created in the company, telling her he was impressed with their conversation regarding her raise a few months ago.

3. Engage in a Conversation, Not a Confrontation

Enter into your salary negotiation with the mindset of engaging in a conversation, not a confrontation. Doing this creates an entirely different atmosphere predicated upon understanding what both sides want and need to come to an agreement, as opposed to creating an acrimonious, adversarial environment.

With the above in mind, begin all salary conversations by discussing how your work has added value, i.e., benefitted the company. *Do not make the common mistake of initiating your negotiation by stating what you think you deserve. This makes the conversation about you instead of the company.* Like it or not, the company only cares about you in relation to the "value add" you contribute to their bottom line. This is not a popularity contest (although research confirms employees who are liked get paid better for comparable work than those who are less liked). Successful negotiation will be based upon what you financially bring to the table! Speak in a manner that will clearly demonstrate your increased market value, based upon goals that were met or exceeded. Many women make the mistake of assuming their boss is cognizant of their accomplishments; this may or may not be true. Therefore, it is imperative you inform your boss of your accomplishments in a professional, confident manner. If your position does not lend itself to reflect a monetary gain to the company in a direct, bottom-line figure, connect the dotted lines between your job performance and the subsequent

"value add" it paved the way for. This may take a little bit of time, but it will become an important ally for your raise if you can quantify how your position and work is clearly linked to the company's bottom line.

4. Carefully Choose Your Words

Words are powerful. They send both overt and covert messages to the listener; therefore, choose your words carefully during the negotiation process. Words can imply confidence or a lack thereof. Phrases such as "you know" and "like" should be avoided, as they lack conviction, power, and persuasion. Refer to a problem as a "challenge." The word "challenge" makes something appear less personal than the word "problem." While negotiating, don't make the process personal—it must always remain solely within the business arena. You are not arguing with anyone, you are having a conversation with a person who represents the best interest of the company. *Choose words that will demonstrate how paying you what you are worth reflects the best interest of the company!*

Additionally, words such as "we" and "my team" reflect a collaborative work approach that women are expected to display in the workforce. Using collaborative words will minimize the risk women face when going against the grain of the expected "good girl" behavior when advocating for themselves. Even though these biases may be unconscious on the part of the employer, they are no less damaging for the negotiator. You may not like this truth, but if we are being realistic, we have to play the game with the cards we are dealt, even if women often get more than their fair share of jokers!

Choosing the appropriate words while negotiating your raise is imperative for promoting good will. It will also increase your chances of getting paid what you deserve. Remember, once the negotiation process is over, you still have to work for the company, and often times with the

person you negotiated with. You don't want to win the battle only to lose the war!

5. Master the Art of Non-Verbal Communication

Anywhere from 50 to 80 percent of all communication takes place non-verbally. Although we may stop *verbally* communicating, it is impossible to stop communicating altogether. We are constantly communicating non-verbal messages. Instinctively and unconsciously we make facial expressions and body gestures that reveal our thoughts and feelings. Therefore, *when negotiating for a raise, your non-verbal communication, specifically your body language, use of eye contact, and tone of voice is critical to a successful negotiation.* Deborah Gruenfeld, a Stanford University professor who teaches leadership and organizational skills, states, "Research shows that your tone of voice and body language matter much more than what you say in determining how others assess you."[13]

Therefore, *what we don't say may be more important to a successful negotiation than what we do say*, because our body language is an inherent part of the conversation. It silently speaks volumes about who we are and how we view ourselves.

First Impressions—Make the Most of Yours

Knowing we have only one chance to make a positive first impression, let's begin at the beginning: with our appearance. It is important we dress appropriately and leave nothing about our appearance to chance. There is a reason the "dress for success" industry is a multi-billion dollar business. Our appearance, accentuated by the clothes we wear, the purse we carry, the shoes we have on, the makeup we wear, the accessories we use, all profoundly impact how others view us upon first glance. It influences how others perceive our authority, credibility, socio-educational status,

13 Sandberg, *Lean In For Graduates*, 2013, pp. 237.

attractiveness, and likeability. Research shows that our credibility is most highly correlated to our appearance.[14]

Make sure your outfit is sharp, crisp, fashionably current, and consistent with your company's corporate culture. When in doubt about how to dress, be more subtle and understated in your appearance than overwhelming! Make sure you don't have any stains on your clothes or runs in your stockings. *Caring about your appearance demonstrates the importance you're placing on this negotiation meeting.* The objective of your professional appearance is to have the people across from you focusing on what you are presenting and requesting while not being distracted by what you are wearing!

Enter your negotiation meeting walking with straight posture. Firmly extend and shake the hand(s) of everyone present while simultaneously looking them directly in the eye. These gestures and mannerisms will set a positive tone and promote good will. *Throughout the negotiation process, maintain good posture at all times by keeping your back straight, chin up, shoulders back and down.* This body language conveys a clear message that you possess self-confidence. Keep your arms relaxed and at your sides; avoid hugging them in front of you or clasping your hands behind your back. Avoid nervous gestures such as the clicking of a pen, throat clearing, leg twitching, hand wringing, etc. *The calmer you appear, the more confidence you exude.* Avoid touching your face, and/or playing with your hair—this distracts from your intended message while unconsciously sending the message that you are anxious, uncertain, or worried.

An interesting note about one's posture:

According to Professor Gruenfeld, research shows that if you stand in a Wonder Woman pose, legs apart and hands on your hips for three to five minutes, your cortisone levels go down and your testosterone level rises. You physically feel more confident. It

14 International Journal of Business and Management, Zhou & Zhang, Vol. 3 No. 2 p. 90.

seems silly when you first try it, but I have done it many times . . . and it works[15]

So give the Wonder Woman posture a try before you enter into the negotiation meeting, you have nothing to lose!

Mirror the other person's body language throughout the discussion as much as is genuinely possible: "Mirroring is when one person adopts another person's body language, vocal tone, and behavior, which builds rapport." Caution: An important exception to this mirroring concept is if you find the other person is leaning away from you—this signals either disinterest or boredom. Find a way to get this person re-engaged in the conversation; this will be demonstrated if they lean towards you.

While your words are critical to any positive discussion, a successful negotiation may hinge upon what is not being said. Therefore, be cognizant of your body language and the body language of those around you.

6. Money Is a Commodity (It Does Not Have Feelings!)

Many women attribute "feelings" to money. This prevents some women from asking for a raise while it holds other women back during salary negotiations. It's important to remember money is a commodity, and like any other commodity, it lacks feelings and/or emotions. Women need to stop looking at negotiations from a "feelings" perspective and view it as merely entering into a discussion about a commodity. Period.

As mentioned earlier, speak in terms of market value by discussing how you've benchmarked your market value to be "x" amount of dollars specific to your position. Speak in the third person, making it easier to create an anchor, i.e., setting one end of the marketing range, which leaves room for concessions. (The concept of anchoring is discussed in detail below

15 Sandberg, *Lean In for Graduates,* 2013 pp. 327.

in item 7b). This allows you to make several concessions throughout the negotiation process, while creating a feeling of good will between the negotiating parties. Concessions help minimize the possibility of anyone feeling taken advantage of and disrespected.

7. Advanced Techniques to Negotiate Your Way to More Money

Based upon your research utilizing the strategies described above, you are now ready to *strategically position* yourself for the negotiation process. However, there are a few more important considerations you must be cognizant of before you begin this conversation. It is essential you are meeting and negotiating with the decision-maker. The decision-maker is the *only* person you should be negotiating with.

For our purposes here, we will define the decision-maker as the person(s) who holds the purse strings (i.e., money) *and* has the authority to grant you the pay raise you will skillfully demonstrate you deserve. Meeting with anyone other than the decision-maker will place one more obstacle in your path and is an exercise in futility.

Consider Sue, a 42-year-old director of a consumer product company. Sue did her due diligence prior to meeting with her supervisor to ask for her long-overdue raise. She was armed with her research, and practiced her presentation to her friends. She even practiced in front of a mirror (to take full advantage of any message her body language might be sending). At the end of her meeting, Sue's supervisor told her she was impressed with both her presentation and all the new roles and responsibilities she had assumed (duties she knew nothing about). Sue's supervisor then concluded the meeting by saying, "Unfortunately, I don't have the authority to give you what you are requesting, but if I did, I surely would."

Therefore, be sure you are meeting with the appropriate person. This may sound like common sense, but experience suggests common sense often has little to do with reality, and is the least common of senses!

7a. Framing Your Position

The following considerations some people may consider manipulation, but I vehemently disagree. Based upon your due diligence, you should have a realistic numerical range that your company is budgeting to keep you as their valuable employee. (Remember, companies want to minimize employee turnover, as the cost of turnover is expensive, and the talent pool is small.) *The pay range—not a specific number—should provide the specific lens through which you position yourself during the negotiation process.* For example, Ellen was being paid $90,000 in her senior management role for a Fortune 500 company. While conducting her research and due diligence, Ellen discovered her salary was not even within the lowest limits of the $150,000 to $225,000 salary range her position was typically paid. Fortunately, Ellen did not make the common mistake of asking for an increased percentage of her salary. Instead she framed her negotiation around the normal salary range for her position, supported by her research (which was between $150,000 and $225,000) and built her negotiations around this numerical range—not her current salary.

Positioning yourself this way is referred to as *framing*, as you are focusing the conversation around a set of facts and values to be negotiated, not a single number. According to Vickie Pynchon, "frames provide meaning through selective simplification, by filtering people's perceptions and providing them with a field of vision for a problem."[16] By utilizing the advanced negotiating technique of framing, Ellen was able to escape the common employer practice of offering incremental increases based upon

16 Pynchon, Victoria, "The Power of Framing and Anchors," Negotiation Law Blog, June 27, 2007.

your current salary. *Framing allowed Ellen to negotiate her pay raise through a very specific lens that included industry standards and what she discovered her company budgeted for her position based upon her in-house research; it did not include her current salary.* She framed her conversation to specifically include and exclude what would serve her best during the negotiation process. Using the techniques described above, Ellen negotiated a new base salary of $195,000 with an added bonus and additional incentives.

7b. Anchoring Your Value—Who Offers Up the First Number?

Many negotiation experts suggest you should wait for the employer to speak first and put a salary number or percentage on the negotiating table. This is based upon the belief that you'll gain critical information about your employer's bargaining position and hints about an acceptable agreement and their accompanying terms. At first blush, this advice appears intuitive; however, "substantial psychological research suggests that, more often than not, negotiators who make first offers come out ahead."[17] This outcome is related to a concept referred to as *anchoring*.

Anchoring during the negotiation process creates a reference point (i.e., an anchor) upon which the negotiations will revolve. Research into human behavior and judgment reveals how we perceive this reference point number is highly correlated to and influenced by any other relevant number that is put on the table in the negotiation process. Because they pull judgments toward themselves, these numerical values are known as *anchors. First offers are known to have a very strong anchoring effect, exerting an undeniably strong pull throughout the negotiation process.* Therefore:

> *Even when people know that a particular anchor should not influence their judgments, they are often incapable of resisting its influence. As a result, they insufficiently adjust their valuations away from the anchor.*[18]

17 *HBR*, "When to Make the First Offer in Negotiations," August 8, 2004.
18 *HBR*, p. 1 8/9/2004.

In other words, any initial reasonable salary raise put on the table influences all other offers. Due to the unconscious nature of anchoring, even the most seasoned negotiating experts are influenced by it (whether they believe they are or not). Except in circumstances where the other side has much more information about specifics related to your negotiation than you do, go ahead and suggest an aggressive, but not absurd, salary increase number or range to anchor the negotiation process in your favor.

Many negotiators, men and women alike, are afraid that an aggressive number will scare, anger, or annoy the employer. Research suggests this simply is not true. This fear is exaggerated, and *most first offers are not aggressive enough, especially when placed by women.* Again, fear becomes an obstacle for women not getting paid what they are worth (by their own doing!).

Go to relationshiptoolbox.com/money-book/tools_negotiate_your_worth.pdf if you would like a copy of "Seven Sure-Fire Tools & Strategies to Negotiate Your Worth."

Finally, your negotiation process is not complete until you've addressed perks and fringe benefits. Fringe benefits include vacation/holiday time, life insurance, health insurance (a benefit whose cost is rapidly being passed onto the employee since the passage of the Affordable Care Act), retirement benefits, maternity/paternity leave, family leave to care for a sick child or elderly parent, etc. Consider a fringe benefit to be anything an employer provides that is not your salary. As with your salary negotiation, a little bit of research on what your company offers and on the industry standard will serve you well. Perhaps you want more paid vacation days, an extended maternity leave, a higher 401k match for your retirement plan, or stock options (if available). Whatever you want to negotiate,

know ahead of time and be prepared to support your request with solid factual reasons.

Having successfully operationalized the negotiation tools described above, you now have one more final step to take before your negotiation is complete; this final step is critical. Failure to take it will come at your own peril! Once you have concluded your salary and benefits negotiation, insist the employer put what has been agreed upon *in writing*. Then insist this document be *signed—the sooner the better*. This protects you from the company "forgetting" what they agreed to. It also protects you from losing your hard-earned salary increase and/or benefits in the event your negotiator leaves the company, or any other unforeseen circumstances appear. If you are told putting your agreement in writing is unnecessary, regardless of the reason provided, very politely but firmly insist on getting this document in writing and signed. In business, it is very hard to win any contract dispute if the agreed terms being disputed are *not* documented and signed by all parties! If the company suggests you are not trusting them, respond with Ronald Reagan's motto: "Trust but verify!" This is business!

One final note: Be cognizant of both the company's fiscal situation and the mood of the person(s) you are negotiating with prior to the commencement of the negotiation process. Timing is critical for a successful negotiation. If the company's earnings were just released and they were poor, and/or if your negotiator is in a bad mood, you would do well to re-schedule this meeting to a time when the overall energy and mood is more positive.

If you are not getting paid what you are worth, it's your responsibility to make sure you do! Place the strategies and tips provided in this chapter into your toolbox and negotiate your worth! Just do it! No excuses!

CHAPTER 5

Your Money/Financial Personality and Its Impact on Your Relationships

"Know Thyself"

—Socrates

Perhaps you have never really concerned yourself with what money represents to you on a personal level. If so, you have lost the opportunity to understand how your personal relationship to money shows up in your professional life at work. It may be inhibiting (if not prohibiting) your ability to negotiate and get paid what you are worth!

As discussed earlier in this book, money is merely a commodity. It does not, in and of itself, possess feelings or emotions. It is a currency. What money represents to you in your life, rooted in a mixture of your childhood experiences, societal influences, and media/pop culture, combined with your self-esteem (reflected in whether you sincerely believe you are indeed "worth it"), will show up in the workplace.

Money, perhaps more than anything else, is fraught with many emotions (often very complex ones). It is these emotions that will significantly influence your pursuit, or lack thereof, of money, directly

influencing your ability to negotiate and get paid what you are worth.

It is imperative you have a firm grasp of these influences and emotions so you can gain an understanding of how they will play out in your career and personal life.

Your Money/Financial Personality

Up until now we've discussed the underlying reasons for the gender wage gap and provided negotiating tools and strategies needed to close it, based upon what you, as an individual, are worth. Now let's shift our attention to discuss your personal feelings and attitudes surrounding money. We will call this your "Money/Financial Personality." This personality information is vital to your wealth accumulation and ability to negotiate your worth, because it will uncover your *emotional relationship to money*, i.e., your attraction to and/or avoidance of it, and how it shows up in your career, investment habits, and intimate relationships.

Although who we are today is greatly influenced by our history, we are not enslaved to the past. It's important women understand what their financial personality is, predicated upon their past childhood experiences, both inside and outside the family. This allows us to be fully cognizant of the influences that impact our ability to negotiate (or not) and get paid what we deserve. Knowing your Financial/Money Personality and understanding how it shows up in your professional life is tantamount to ensuring you get paid what you are worth.

Your relationship to money is not just about money—it is about how you feel about money!

Daniel Goleman, author of the best-selling book *Emotional Intelligence: Why It Can Matter More Than IQ*, discusses the role emotions and your ability to effectively handle these emotions play in your personal and professional success. This same concept can be applied to your financial

situation. Being cognizant of your feelings about money, coupled with your ability to effectively manage these feelings, will have a profound impact on your ability to accumulate wealth. It will also influence your ability to insist you get paid what you are worth.

Your Feelings about Debt

Debt is defined by Merriam-Webster as "the state of owing money to someone or something." Debt is an obligation that needs to be paid off. There are many different types of debt: mortgages, credit card debts, student loans, car loans, and home equity loans to name a few. What is critical to this discussion is the fact that *all debt is not created equal!* Financial experts differentiate between "good" debt and "bad" debt. A CNN article defines "good" debt as "anything you need but can't afford to pay for up front without wiping out cash reserves or liquidating all your investments Bad debt includes debt you've taken on for things that you don't need and can't afford." Good debt refers to a purchase that will usually accrue value over time, i.e., a mortgage, or provide a sustainable means to increase your earning potential, i.e., a student loan.

Bad debt is best represented by credit card debt used to buy nonessential goods or services that you cannot afford, such as pricey vacations, expensive clothing, jewelry, and fancy meals in restaurants, all paid for with high-interest-yielding credit cards. If you make the minimum monthly payment on these credit cards, by the time you pay these purchases off, you will have paid more in credit card *interest* than the *cost* of the original purchase! This is an egregious mistake made by many people. You are essentially throwing your hard-earned money away by paying off credit card interest for a lifestyle that is unsustainable, and one you can ill afford! Living beyond your means using credit cards will come back to haunt you—it is only a matter of time.

Your Feelings about Financial Risk

Now let's turn our attention to financial risk—the second important financial principle you must understand as it relates to your personal relationship to money. Defined by BusinessDictionary.com, financial risk is "the probability of loss inherent in financing methods which may impair the ability to provide adequate return." In other words, your risk tolerance is related to your ability to make a financial investment/decision, without knowing for certain the outcome of that investment, and feeling secure with your decision anyway.

Make no mistake about it; your ability to seek pay commensurate with your worth and the ability to appropriately spend and/or save money to achieve your financial goals will be directly influenced by your Money/Financial Personality. Money's ability to increase your happiness by enhancing your lifestyle is not just about how much money you earn. It's about what you *do* with the money you make. One of the most important financial traits to consider is your comfort level with debt and risk-taking. Why? Quite simply, many, if not all, of your financial decisions and choices will be guided by these two basic financial principles. Please don't fret if you've never made the correlation between your comfort level with debt and financial risk-taking and your ability to accumulate wealth before—most people haven't. But that is about to change for you in this chapter.

Your Money/Financial Personality

Financial risk involves directly linking your emotions with your money.

DISCOVERY EXERCISE ONE:
Take a Good Look at How You Handle Risk

Answer the following questions as a means of understanding your comfort level with debt and financial risk-taking. It is important to remember there are no right or wrong answers to these questions. The importance of this exercise is to increase your emotional self-awareness and understanding of these concepts.

Investments:

1. Are the financial gains you can potentially make on an investment worth the risk?

2. How emotionally comfortable are you making an investment that could potentially lose money?

3. Are you completely risk-averse, so that regardless of how much potential money you may earn from an investment, you don't want to risk losing any money at all?

4. Do you get a queasy feeling in your stomach when the news reports a drop in the stock market?

5. Will you refuse to take even the most prudent investment risk because there is a chance, ever so slight, that you might lose some money?

6. Are you always looking for the latest and greatest get-rich-quick scheme? Have you ever invested in any?

Gambling:

1. When playing cards, will you agree to "double or nothing" your winnings?

2. Do you refuse to even spend one dollar on a lottery ticket because it is a total waste of money?

3. Are you comfortable gambling or betting? If so, do you have a maximum amount of money you are comfortable gambling with, win, lose, or draw?

4. How much money are you comfortable losing in a card game with friends? At a community fair?

5. From an emotional perspective, do you know how much money you are comfortable losing?

Riding the Ups and Downs of Financial Wealth

1. Do you lose sleep or feel anxious or sick if you experience a loss of income for any reason?

2. Do you get an adrenaline rush when your earnings are increased for any reason?

Career

1. Will you seek a new position that takes you out of your comfort zone because it will increase your earnings, or provide the potential to do so in the near future?

2. Will you not seek a new position, regardless of how much more income it might provide, because you feel under qualified for the job?

3. Will you refuse to take on a new role/position at work, regardless of how lucrative it might be, because it will require either too many hours of work and/or travel away from home?

Your Money Behavior

Now it's time to examine how you operate around money in your daily life. (If you are in a business or marital relationship, suggest that your partner do this as well for some insightful conversation.)

DISCOVERY EXERCISE TWO
Identifying Your Daily Money Behavior

How do you relate to money in your daily life?

1. *What are your purchasing habits?* Do you buy the floor model to get a great deal, even if you risk quality? When you are shopping for a big-ticket item, like a new car, do you comparison shop first on the Internet and then in several different stores? Do you make decisions about big-ticket items on your own, or do you check with your spouse first?

2. *What are your investment habits?* Do you prefer long-term conservative investments, choosing lower yield as a trade-off for safety? Do you enjoy playing the stock market? Are you a day trader? Do you prefer to have a diversified investment portfolio?

3. *How long does it take you to make a financial decision?* Do you make decisions impulsively? Or do you weigh all the data carefully before making a commitment? Do you reach decisions intuitively, or do you demand substantive, painstaking analysis and information to guide your decision?

Your Money Philosophy

Patty / Ann

DISCOVERY EXERCISE THREE
Understanding Your Money And Risk Philosophy

Risk Personality

Let's figure out what you think and feel about financial risk. The stories you read, hear, and pay attention to influence your perception of risk. You will filter in or out the positive stories of risk and reward, or the tragic stories of loss, depending on your personal financial risk attitude, or your mindset. *Your mindset is the critical factor that dictates whether you focus more on the success stories or the failure stories of risk-takers, along with how you interpret these stories.* (See Chapter Three for a more thorough discussion of the mindset concept and its influence on your relationship to money.) Either way, the media and pop culture will have an invisible yet very strong hand in influencing your willingness to take a risk.

Traditional and social media love to report the drama of business success and failure, evidenced by the wild popularity of the TV show *Shark Tank*, where entrepreneurs present their business strategies to gain funding from wealthy investor celebrities Barbara Corcoran, Mark Cuban, Kevin O'Leary, Robert Herjavec, Daymon John, and Lori Greiner. We all love to read how an ordinary person achieved the American Dream and hit payday with an idea they scribbled on a napkin at a cocktail party. Silicon Valley in California is rife with twenty-somethings making it big in the start-up industry. And who

hasn't marveled at the teenager who started a multimillion-dollar business in his PJs in his bedroom with only a laptop? (Three of my four young adult children are currently working for start-up companies that didn't exist when I began writing this book!)

So ask yourself—when you watch a television show like *Shark Tank*, or hear about a friend who is quitting their job to venture out to create an app, what is your reaction? *I want to be there too!* Or, *I wish them luck, but never me! I'm not cut out for it!*

Most people are unaware of their financial risk personality. The exercise below will help you identify yours. You don't want to discover how you feel about financial risk when you are in the middle of a financial catastrophe. It doesn't serve you well to start looking for your life vest when the ship begins sinking.

Let's call your attitude toward risk your "risk personality." The formation of your "risk personality" is influenced by four major sources: family messages, adult experiences, friends and colleagues, and the media/pop culture. Dr. Victoria Felton-Collins, psychologist and certified financial planner, states, "There is a difference between prudent risk and wild gamble."[19] It is imperative you understand how you feel about risk if you are to become financially savvy and capable of reconciling financial conflicts in your marriage.

Family Messages

How your parent(s) raised you to think about money influences your adult perception of financial risk. (In Chapter Two we discussed in detail how boys and girls are raised differently when it comes to the handling of money.) Childhood memories have a

19 Felton-Collins, *Couples and Money.*

tremendous influence on your adult money personality. Most of your money behavior as an adult comes from following in your parents' footsteps or rebelling against them. People bring an array of conscious and unconscious beliefs, attitudes, and feelings about money into their adult life and marriages, often having absolutely no clue about how they were formed. Without this clarity, your ability to understand and manage your finances becomes quite challenging.

Conscious and unconscious attitudes about money are internalized by approximately age twelve. These attitudes were formed by childhood experiences where money values were covertly and overtly communicated. The reason why many money fights between couples are left unresolved is because each partner's unconscious beliefs and attitudes about money are never brought into the open and discussed. Since many of these beliefs are unconscious, you are, by definition, unaware of them. What remains unknown and undisclosed in one's unconscious remains unresolved in one's relationship and misunderstood on one's financial balance sheet.

Growing up, my parents consistently struggled to pay the basic expenses for our large family (two adults and five children), leaving vacations and restaurant experiences totally non-existent. Since this was long before the days of reality TV, I was only aware of the lifestyle everyone around me lived, and we were all in the same rickety boat. Even before my mother was widowed at thirty-six years old with five kids, I never recall my parents fighting or even talking about money. I never felt deprived of luxury, although my family clearly was. My father's massive heart attack at forty-two years old

was surely related to the stressors of holding down three jobs amidst unrelenting financial pressures. As an adult, I asked my mom about this, and she replied, "Why fight about money we didn't have? It served the family much better to just make do with what we had." Hence, you can easily see the roots of my very practical attitude about money on the one hand, and determination and drive not to be in a similar position with my own family on the other hand.

If your childhood experiences with money were negative because all you can remember is your parents fighting about money (how much money was being spent and on what, credit card debt, accumulating unpaid balances, etc.), you may be risk-averse as an adult. You might vow to never repeat your family-of-origin's negative experience with money. I don't know your life's experience and what you learned at home, but I am 100 percent confident that it would behoove you to think about it and learn from it, as it helps you understand where your head is now, as an adult, when faced with financial challenges.

Adult Experiences

Have you experienced the consequences of financial risk as an adult? Once you begin taking risks as an adult, the outcome of your decisions, and your attitude toward success or failure, will influence your risk personality. Two decades ago, I was quite hesitant to add an entrepreneurial consultant business model to my successful traditional private psychotherapy practice model. The private practice model is referred to as an "hours for dollars" model. The entrepreneurial business model I have transitioned into allows me to achieve my goal of helping more people be successful in business

and life by leveraging my time. Initially, this new entrepreneurial business model was quite unsettling, raising my risk tolerance to uncomfortably high levels. But my husband's unwavering support went a long way to ward off any financial doubts I felt. As I saw success come my way with these transformations in my work, I was more able to welcome the change.

The questions below will help you identify your money and risk philosophy:

1. *Are you basically optimistic or pessimistic* when it comes to your relationship with money? Do you have confidence in your ability to make money? Do you trust in the benevolence of the universe? Do you worry incessantly about financial harm befalling you and going broke? Do you believe that money is a fluid resource that may come and go many times in your lifetime? Or do you view money as an asset that isn't easily replenished once it is lost?

2. *Do you consider risk-taking a necessary evil,* like paying taxes, or an exciting adventure, like mountain climbing? Do you get a sick feeling in your stomach or a pleasant adrenaline

rush when you are taking risks? Is the absence of risk boring to you or comforting? When you look back on your life, are the times you took your biggest risks your best memories or your worst?

3. *How does money represent freedom to you?* Do you dream of earning enough money so that you won't have to work anymore? So that you can hire housekeeping staff and buy a private jet? So that you will not be indebted to anyone? If you were able to achieve the wealth you long for, what privileges would be available to you that you don't have now? How would greater wealth influence the overall quality of how you live your life?

4. *How does money represent security to you?* Does the provision of material needs give you peace of mind? Have you ever had enough money and still felt poor or felt afraid of losing it all? Is there ever enough money for you to feel secure? How much is enough? Do you feel that money is meant for spending, or do you prefer to save for a rainy day? Do you save twenty years away for retirement or only five years ahead, because anything can happen?

5. *How does money represent power to you?* Do you aspire to manage a large company with thousands of employees working for you? Do you appreciate the status money provides? Is it important to you to influence people's actions with your money? How have you felt more powerful when you have had money, compared to when you haven't?

6. *How does money represent love to you?* Do you expect your partner to take care of you financially, as a demonstration of their love? If you have discretionary money, do you prefer to spend it on loved ones? Do you ever attempt to buy love through giving? When you receive a gift from a loved one, what does it mean to you? If you don't receive a gift when you expect to, how much importance do you give the oversight? How much does it matter to you what a loved one spends on a gift?

7. *Who are your role models,* the people you admire the most when it comes to financial success? Do you wish you were the one who had thought of Apple, Uber, Facebook, or UnderArmour? Or would you just as soon enjoy the comfortable retirement of a corporate CEO? Who in your family, neighborhood, or circle of friends has achieved the kind of financial success you dream of acquiring?

Money Issues in Your Marriage or Business Partnership

The majority of the information in this book has addressed the challenges professional women face in the workplace to get paid what they are worth. We discussed all the reasons underlying the gender wage gap and provided concrete negotiating tools and techniques needed for each individual person (woman or man) to get paid what they deserve.

Since my work as a relationship expert has placed me in the unique position of helping people in both their professional lives (as a business consultant and executive coach) and their personal/married lives (as a licensed psychotherapist), I cannot resist the temptation to include in this book a discussion of the role money plays in one's marriage. After all, the majority of people reading this book will, I certainly hope, at some point be actively involved in an intimate relationship. Therefore, we might as well address the 800-pound gorilla in the middle of most marriages; i.e., money! Additionally, professionals who have a "business spouse" will find this information to be an eye-opener. Not unlike many marriages, a majority of business partnerships are dissolved over differences of opinions, attitudes, and values surrounding money.

If you are in a partnership: Are you two peas in a pod, or is it amazing you can reach agreement on any financial decision? Do you balance each other out well, or do you both tend to lean toward one direction? Do you never cease to amaze each other regarding how differently you view money? Are you comfortable with how you currently compromise to reach a financial agreement?

For the most part, your professional relationship to money mirrors your personal relationship to money. Hence, the issues that sabotage your financial success at work will plague your marriage and personal life as well. As I mentioned earlier in this book, no amount of love will overcome constant, nagging, pervasive money worries. I've seen that debt and love are inversely proportional; as debt increases, love diminishes. This is not to suggest that when this happens these couples were in their marriages for the money. For many couples I've worked with over three decades, nothing could be farther from the truth. But there is no denying the fact that lack of money and the realities of financial troubles will erode the most loving, stable marriages.

On the other end of the spectrum, when there is more than enough money to go around, spouses who possess a radically different view of the role money plays in their lives (i.e., how much money should be spent, how much should be saved, what types of investments should be made) also come face to face with the complex and emotionally complicated role money plays in their relationships. There is a reason why fighting about money is the number one reason stated for divorce (followed by sex), crossing all socioeconomic levels.

Money Motivation

One factor that powerfully influences an individual's attitude toward money is what we will call "money motivation." It's not enough to work out all of your various feelings about taking risk and going into debt. That's important, but equally important is the recognition that individuals come from different approaches to lifestyle and debt. This is due to not only childhood experiences and risk aversion, but also unconscious motivations. These unconscious motivations impact relationships in ways that often surprise partners when they unexpectedly show up in their lives.

There are four primary money motivators that drive people: freedom, security, power (control), and love. These motivators will drive your daily choices related to money, professionally and personally. They will influence your spending and saving habits, your career choice, whether you ask for a raise or seek a position that offers you greater financial rewards, how you interact with your spouse about money, and what you teach (or don't teach) your children about money.

To be clear, *no specific money motivation is more right or honorable than another.* What you think may be motivating you, or someone else, may not at all be the case. A person may spend a great deal of discretionary income on family members, but what appears to be generosity could be a clever (unconscious) disguise for a need to feel self-important or to manipulate relationships. Conversely, the person who appears to be solely motivated by his ego may actually want to achieve power so that he can provide generously for his family. The way in which money is handled, whether it is saved or spent, and on whom and what, is a key indicator of what it represents for the person who holds the purse strings. In marriages that are not

a true partnership (but rather, a one-up versus one-down power play), money is often a manipulator for power and control, which significantly compromises the intimacy of the relationship.

The giving or withholding of money represents power, control, and influence.

In my experience as a psychotherapist, often a significant difference in tolerance for risk causes strife between an otherwise happily married couple. She feels like she's jumping off a cliff, and he feels exhilarated by the ride. Sound familiar?

Let's discuss your money personality to gain an understanding of one of the most explosive issues: tolerance for risk. Again, we are in that arena where more or less tolerance for risk is neither good nor bad, but conflict between you as a couple can often occur because one of you is not feeling safe, and the other is feeling stifled.

It is my hope that the exercise below will shed some light on this emotionally charged topic, restoring your marriage to fiscal sanity and preventing your business from collapsing under the weight of irreconcilable financial differences.

DISCOVERY EXERCISE FOUR
Identifying Your Basic Orientation Toward Financial Risk and How It Resonates—or Does Not—with Your Partner's

Complete the discovery exercise below to discover your basic orientation toward risk, thereby increasing your understanding about your attitude towards debt and money.

Circle the number that most applies to you. Now ask your business partner or intimate partner to do these exercises too.

Risk-Averse		**Risk-Tolerant**		**Risk-Inclined**
1 2 3	4 5 6	7 8 9 10		

Where are you and your partner on the vast spectrum of financial risk tolerance?

Let's now move on to discuss healthy ways a couple can handle differences regarding financial risk.

Compromise and Effective Communication

It is rare for two people to agree on all issues all the time. Therefore, the ability to compromise becomes essential when dealing with finances, at work and at home. The only way to compromise

is through effective communication. The most important aspect of compromise is being crystal clear on communication about exactly what the issue is that requires compromise. This sounds like common sense, but some couples think they are compromising on the same issue, when they are actually trying to compromise on two different ones. Without effective communication, misunderstandings and conflict erupt, making compromise unattainable.

DISCOVERY EXERCISE FIVE
Family Influence on Financial Risk Personality

Research shows men and women hold different values and attitudes about money. These differences are operationalized in how a person wants to spend and save money.

Explore the following questions below to understand how your family of origin influenced the development of your financial risk personality. You might sit down with your partner over a glass of wine or a cup of coffee and start up some very interesting dialogue about your response to these questions!

1. *What were the messages you received about risk from your family?*

Was it, "Nothing ventured, nothing gained" or, "Better safe than sorry"? What were the actual expressions about money and risk you heard in your house, at the dinner table, or in conversations between your parents? What kind of risk-taking in employment did your parents take? Were your parents loyal "company people" or entrepreneurs? Did you grow up in a "traditional" home where your dad worked full-time and your mom stayed at home raising the kids and running the house? If so, do you know the financial arrangement between your breadwinner dad and your stay-at-home mom?

2. *What was your actual experience with money like as a child?*

Do you ever remember worrying about whether your family had enough money while growing up? Did you get what you needed as a child? Were you given an allowance? Did you have any of the luxuries of life that only money can afford, i.e., family vacations, fashionable clothes, new cars, etc.? Where did you perceive your family fell on the food chain: wealthy, upper middle class, middle class, lower middle class, or poor? What kind of neighborhood did you live in? Was your home/apartment run-down or well maintained? Did you attend private or public school? Who paid for your college or trade school, or any other educational experiences you may have had beyond high school? Did you take out debt for your college or graduate school education?

3. *How did your parents manage their money (if you know)?*

Did your parents invest in the stock market, real estate, mutual funds, savings bonds, IRAs, 401Ks, etc.? Did they ever lose a significant amount of their assets? What was their attitude about savings and loans? What kind of assets do they own now, as a result of their earlier financial decisions? Do you know if they plan on leaving you an inheritance, and if so, in what form (money, real estate, stocks, etc.) and approximately how much money it will be worth? Did your parents ever argue about money? Do you recall your parents ever stressing about money? Did your parents never discuss money at all, leaving you completely unaware of your family's financial situation?

4. *What messages about risk did your parents learn from your grandparents?*

Were your grandparents immigrants who risked everything to come to this country? Did your grandparents start or work together in a family business? Is your family inclined to an entrepreneurial spirit, or are they more bound to the traditional corporate world when seeking financial security?

Now that you have a better understanding of your feelings about financial risk, and in particular how that resonates with a partner, let's take a closer look at other aspects of your money personality and how it impacts your relationships.

DISCOVERY EXERCISE SIX
Establish Guidelines for Money Management and Decision-Making

Following are some of the decisions you will need to make with your spouse regarding money. With an overall conceptual conversation about risk and spending habits, you can now drill down to the basics, the cornerstones of daily spending and sharing money. Below are some topics to discuss. I recommend you take out your laptop or a pad of paper, and a bottle of wine or a big cup of Joe and make a date of it, discussing these hot and important topics.

Joint or Separate Checking Accounts

Some happy couples swear the key to their successful relationship is keeping all of their money separate. These marriages acknowledge the financial complexity with which many individuals enter into marriage. For example, if one spouse attended graduate school in the field of medicine or law, they might have easily accumulated $100,000 of student loan debt. The stark reality is marriage is as much a legal and financial arrangement as it is a romantic relationship. Couples who ignore the financial aspect of their marriage do so at their own peril. Therefore, although many couples feel totally committed and loyal to each other, they believe

their commitment has absolutely nothing to do with bearing any of the debt their partner carried into the marriage. Hence, finances are kept separate. They recognize the significant differences in their spending patterns, with each individual wanting to maintain autonomy over their own money. Separation keeps the peace. It prevents couples from fighting about how much money the wife spends on a pair of shoes or the husband spends on a set of golf clubs when the monthly credit card bill arrives.

Conversely, couples who merge their finances consider this to be a source of strength in their relationship. They view themselves as one financial unit and can't conceive of marriage with separate checking and/or savings accounts.

Neither strategy is wrong. The decision is up to each individual couple to decide which arrangement works best for them, taking into account their unique situation, their individual tolerance for risk, and their personal preferences. This decision, to merge finances or keep them separate, might also shift over time. A couple might start their marriage with separate finances and then merge them years later, perhaps when one partner decides to begin their own business and lacks income while getting their entrepreneurial venture off the ground.

Before Emily met her husband Bill fifteen years ago, she was single for many years and in total control of her own money. She was debt-free and worked hard to keep her finances in order. When Emily and Bill married, they merged their finances completely. Although Emily was a successful, modern career woman, she couldn't

imagine she and her husband keeping their finances separate. As she told me, "It never occurred to me to not join all our money." Even though Bill carried debt and Emily didn't, and many new monthly expenses would now be shared, keeping their money separate was inconsistent with their view of marriage. Emily recalled, "Before I met Bill, I said that I would never let my checking account fall below a certain level, I would never carry credit card balances, and I would never be willing to pay someone else's debt with my hard-earned money. Guess what? I've done all those things since marrying Bill, and although it was difficult and uncomfortable for me, it was not as tragic as I had always imagined it would be; it wasn't the end of the world."

Discretionary vs. Fixed Costs

You might think what constitutes discretionary spending and fixed costs are self-evident; I urge you to think again. Obviously the mortgage or rental payment and the car payment are fixed costs. But what about the manicures and pedicures some women wouldn't even dream of forgoing every week? Or the good-natured sports betting or the annual golf trip some men can't live without? What are these costs considered to be: discretionary or fixed? The answer will depend upon whom you ask. Therefore, you and your partner must be crystal clear on what you consider to be a necessity of life (i.e., a fixed cost), activities for which you would be willing to forgo other things to ensure they stay within your budget. (See the following chapter for items you must consider when creating a budget.)

How Much Money on Discretionary Items Is Considered to Be Too Much Money?

Perhaps you would not think twice to spend $100 on a concert ticket or sporting event, whereas your partner might think those prices are way outside the budget. If you and your partner join all your money together, it's critical you agree to a specific number you are both comfortable spending on discretionary items. Any purchase over that agreed-upon amount will not be made until you consult with your partner. This practice will prevent you from blowing your budget, with the predictable money fights ensuing.

DISCOVERY EXERCISE SEVEN
Money Management AND Decision-Making If Your Spouse Is Also Your Business Partner

With your partner, clearly articulate (verbally or in writing) your understanding of personal and business money management decisions. Additionally, clearly identify responsibilities for business decisions that impact your business or personal finances. Here are some options:

1. All our money is joint. Therefore, we will equally share all money-related decisions.

2. Although we will fund the business with joint money, we agree that I must check with you *only* if the business goes over budget.

3. I agree to consult with you on any business or household decision requiring more than $XX amount.

4. Since our money is separate, I will check with you only if my financial decisions will affect our lifestyle or joint personal possessions.

5. I agree to handle the bookkeeping for all of our household bills and for the business.

6. I will take care of paying my personal and business bills. I expect you to do the same.

7. Although we operate this business as full partners, I leave the daily financial management to you. However, I expect you to involve me in financial decisions requiring additional investment over $XX as a one-time expense or $XX monthly.

8. We agree I will make financial decisions related to operations, and you will make financial decisions related to marketing and sales, as long as the decisions are consistent with our business plan and are not more than five percent over budget.

DISCOVERY EXERCISE EIGHT
Appreciating Money Style Differences

You and your partner should complete the following exercise separately, and then share your responses with each other.

1. When it comes to money management, my greatest strength is _____.

2. When it comes to money management, my spouse would say your greatest strength is _____. (Do numbers 1 and 2 match? If not, discuss why not.)

3. When it comes to money management, my spouse's greatest strength is _____.

4. When it comes to money management, my spouse would say your greatest strength is _____. (Do numbers 3 and 4 match? If not, discuss why not.)

5. We recognize these money style differences between us: _____.[yes or no?]

6. We're lucky those differences exist. We complement each other in the following ways, making us a stronger team: _____.

7. When we get polarized and rigid about our differences, this is what I do that contributes to the problem: _____.

8. When we get polarized and rigid about our differences, this is what my spouse does that contributes to the problem: _____.

9. I want to come to celebrate the money style differences between us. To that end, I agree to _____.

We acknowledge that the different values and behaviors we have about money are rooted in our family upbringings and our own personal financial personalities, which we just discovered earlier in this chapter.

Now we will discuss these differences, not from a judgmental place, but from a factual perspective. This will help lead us to a greater understanding and appreciation of each other.

Follow these ground rules for productive discussions about money issues:

One: Discuss Money Concerns Only in a Designated Meeting Scheduled at the Right Place and Time for Both Parties

Since most discussions about money can easily become volatile, ask your spouse for a meeting at a mutually convenient time, preferably in a place that allows you to talk uninterrupted and face-to-face. As a rule of thumb, the more emotionally charged the issue is, or potentially may become, the more important it is you follow this ground rule.

Two: Agree that You Will Make No Significant Money Decisions as a Knee-Jerk Reaction

Avoid asking for any major changes to your current financial circumstances until the appropriate time for discussion with your spouse. This will prevent further polarization of the relationship, which may have already begun. If you make a decision or demand based on an argument, cancel the agreement or request made in haste, and discuss it at a more appropriate time when cooler heads prevail. In your conversation, approach the meeting with the tone of partnership rather than accusation or blame. Expressing concern over the family's financial situation will create good will, which will allow your spouse to actively listen to your genuine concerns.

Three: Discuss Money Concerns before They Become a Crisis

When you are in the midst of money difficulties, sometimes it is too painful or frightening to look at the reality of your situation. Procrastinating discussion until finances are at a crisis level is not an effective way to solve the problem. It is much more effective to deal with financial issues as soon as you feel their strain on your relationship. The moment the *Titanic* hits the iceberg is not the time to determine whether there are enough lifeboats onboard.

Allow the Money Style Differences between You and Your Partner to Work to Your Advantage

Money conflict is the most frequently cited reason for divorce and the hardest issue for couples to resolve effectively. As a relationship

expert who has helped thousands of couples handle money conflict, I'm here to tell you it can rip even the most loving of relationships to shreds. Money differences will always be there—that's normal, and human. It's up to you and your partner to decide whether you will make the differences between you work to your advantage, instead of walk you down the road to divorce. Jason and Joy came to me for help. Jason articulated a positive money attitude between his wife and him very well:

My wife, Joy, and I have the "stop and go" approach to spending money. I'm the driver, and Joy is the brakes. I'll call her from the office and tell her I want to buy something. She'll tell me I can't because money is too tight this month. She has a better handle than I do on how much money we have, so I've learned to listen to her.

Jason has learned from experience to trust Joy's system for evaluating financial purchases. Frequently, one partner is the big dreamer with ideas and chutzpah to act. If lucky, this person will team up with a partner who injects a regular dose of reality, a knack for details, and cautious money management—a complementary partnership.

When your marriage is on solid ground, this approach may work like a charm. When the marriage is experiencing emotional difficulties (as all marriages do), this approach might create resentment between partners when the partner who is told "no" begins to feel controlled. At this point, the "stop and go" approach

may not feel as if it is coming from a place of support and love, which was its original intent. When each individual approaches spending based on mutually agreed-upon couple goals, both short- and long-term, fighting over individual purchases will be less likely to occur.

Go to http://relationshiptoolbox.com/money-book/Money_Fights_Quiz.pdf and take Dr. Patty Ann's "Stop Fighting About Money" quiz.

Bottom line, like most financial investments: If you invest in your marriage hoping for wild gains from short-term effort, you'll likely be emotionally estranged or divorced in a matter of a few years. If you recognize that your commitment is for the long haul, you'll figure out a way to reconcile the differences you discover. You'll be like those sweet old couples we always admire who have been married for fifty-plus years and still seem to genuinely adore each other!

CHAPTER 6

Budget or Bust: The Power of Budgeting Done Well!

"A budget is telling your money where to go instead of wondering where it went."

—John Maxwell

Knowing your money goes out as quickly as it comes in is not a budget or a financial strategy! A budget as defined by the Miriam-Webster dictionary is "an amount of money available for spending that is based on a plan for how it will be spent." Sounds simple enough, right? Yet many women never create a budget; hence, all they truly know about their money is that it goes out as quickly as it comes in.

During this chapter you are going to be provided with all the information you need to create a budget: one that is unique to your lifestyle, financial reality, and goals. Once created, you will be in the enviable position of knowing exactly where your money goes, every single month. *You will be in control of your finances, instead of having your finances control you.* What a great accomplishment!

Let's Begin at the Very Beginning

Have you ever asked yourself, "Where did all my money go?" If so, you are not alone, most people have. A budget will provide the answer to this question, which may appear daunting at times. Creating a budget involves making a conscious decision about how much money you're going to spend on every item that has a monetary value attached to it, before you actually spend the money on these said items. The creation of a budget requires careful deliberation and thought. It should be fueled by realistic goals. And yet, that's the easy part! The most difficult aspect of a budget is sticking to it!

In many ways, budgeting is similar to our attempts at weight loss and dieting. You commence your dieting journey with the unrealistic goal of losing twenty pounds within four weeks. You tell yourself you are going to limit yourself to only two meals a day and cut out all snacks and alcoholic beverages. In essence, you embark upon a no-frills, Spartan diet. Armed with your newly minted weight loss goal, you get yourself all psyched up and begin dieting when? On Monday, of course! By the time a week goes by, however, the diet has gone out the window, and with it, your goal of losing twenty pounds in four weeks. So what happened from the time you earnestly began your diet to when you threw it out the window a mere seven days later? It's not that you were insincere about your intention. The problem lay in the fact that your goal was lofty and unrealistic. The goal created a no-frills, Spartan diet that would become impossible for any mere mortal to stick to!

If we are honest with ourselves, we really all know what we need to do to lose weight, i.e., eat healthy, and burn more calories and fat than we take in. It is not a lack of information that derails our dieting, it is the fact that we set ourselves up to fail with unrealistic goals.

For many people, *the inability the live within a budget falls prey to the same issue: unrealistic goal setting.* People create a budget with the sincere

ambition of sticking to it. Just like weight loss and dieting, maintaining a budget requires self-discipline and determination. And similar to weight loss and dieting, the main reason people don't stick to their budget is predicated upon unrealistic goal setting.

Remember, *the goal of a budget is to be able to track how much money you spend and on what specific items to achieve your financial goals. It is not to force you into a lifestyle of unrealistic austerity.* Therefore, as you begin to assign different monetary values (dollars) to the items in your budget, it is imperative you are realistic. If you create a budget that denies you all the good things in life you enjoy that require money (and you know from reading this book that many of the good things in life aren't free), you are setting yourself up for busting your budget before you have even begun. Living within your budget may not allow you to partake in all the luxuries of life, but it should allow you to partake in some of them!

Patty Ann

Budget Exercise One: Know Thyself

Ponder these questions and write down your thoughts and answers in the spaces provided below. Do not pass judgment on who you are, just be totally honest with yourself! If you are in a marriage or intimate relationship, discuss your answers with your partner. *Take your time answering this very important first question.* If you rush to question two, your budget won't be based on a realistic assessment of who you are and your personal needs and preferences, so please DON'T skip or rush over this vital step in your budget-creating process.

1. *Know Yourself.* Be cognizant of who you are and the lifestyle that you like (or want) to live. Be completely honest with yourself, or you will surely bust your budget right out of the gate.

2. Make a *thorough and honest assessment of your current financial situation.* Not what you would like it to be, but what it currently is!

3. Once you've completed question two, *think long and hard about where you can realistically cut back* your monetary obligations, no matter how large or small.

4. If you have *debt (and most people do), can you find ways to restructure it* so you will pay lower interest rates?

5. As you review your financial reality, *can you think of practical ways to add income*, if you think that will help achieve your budgetary goals?

6. Create a *list of your short-term goals and long-term goals.*

7. *Emotionally commit* to your budget. Being emotionally invested in your budget will exponentially increase your chances of sticking to it during difficult financial times.

8. Create a *visual or written reminder.*

If you are the kind of person who responds to visual images to keep you on track (like the dieter who puts on her fridge a photo of the pair of jeans she wants to fit into!) then consider putting visual or written reminders on your wall, in your purse, or on your desk. Use a photo of your retirement home or your dream vacation, or write something like, "Sticking with the budget today?" Whatever works to wake you up, remind you of the plan, and keep you focused and on track.

In the final analysis, your budget should be considered a tool you create to achieve your financial goals. Like any other tool, its success is based upon how you use it. If you create a realistic budget you can live with, the budget will achieve its goal of helping you live a financially healthy life. If you create a budget that you cannot possibly live with, you will remain financially stuck or perhaps sink even deeper into financially troubled waters; the budget will render itself totally useless to you.

Getting Down to the Nitty Gritty: Putting Your Budget Plan Together

Now that you've taken a long, hard look at your financial self, grab your computer and find a quiet place to work, free of all distractions. This means shutting off your phone and turning off all email and any other message notifications you get on your computer. You might want to use a financial software program (a simple one) or an Excel spreadsheet. It doesn't really matter, as long as you're comfortable with the form you use and are able to keep track of your items and numbers attached to each item.

You can create a budget using a daily, weekly, bi-monthly, or monthly timeframe. Again, it doesn't really make a difference. For our purposes here, we are going to utilize a monthly framework.

Budget Exercise Two: Estimating Monthly Income

The best way to understand where your money goes is to know how much money you have at this very moment (not what you once had or what you hope to have!). This starts with estimating your total yearly income, which includes salary, bonuses, interest on investments, sales commission, child support, etc.

Fill in the charts below to learn how much money you earn in a year.

ESTIMATING YOUR YEARLY INCOME BY THE MONTH:

Monthly Paycheck	$	x 12 months	$
Any Government Checks:			
Monthly Social Security	$	x 12 months	$
Monthly Social Security Disability	$	x 12 months	$
Investments:""""			
Quarterly Stock Dividends	$	x 4 months	$
Real Estate Income	$	x 12 months	$
Other Investment Income	$	x 12 months	$
Other Sources of Income:			

Monthly Child Support	$	x 12 months	$
Monthly Alimony	$	x 12 months	$
Monthly Inheritances (trust fund, other)	$	x 12 months	$

Monthly Gross Income: How much money you earn before any other monies are taken out of your payment.			
Source of Monthly Gross Income	$	x 12 months	$
Total Estimate of Your Yearly Gross Income by the Month:	$	**x 12 months**	$

ALTERNATIVE METHOD FOR ESTIMATING INCOME ON A MONTHLY BASIS

INCOME	$
SALARIES & WAGES (NET)	$
COMMISSION CHECKS	$
BONUSES	$
DIVIDENDS	$
MONEY/CASH GIFTS	$
INTEREST	$
TIPS	$
RENTAL INCOME	$
INCOME TAX REFUNDS	$
PENSIONS	$
ANNUITIES	$
Total of Monthly Estimated Income	$

Patty / Ann

Budget Exercise Three: Estimating Fixed Monthly Expenses

FIXED MONTHLY EXPENSES

Fill out the chart below to see what your fixed expenses or costs are. These are expenses that you must pay every month. The amount does not fluctuate.

Housing (mortgage/rent):	$
Home Equity Loan Payment:	$
Homeowner's Insurance:	$
Renter's Insurance:	$
Maintenance/Repair Fees:	$
Condominium Fees:	$
Annual Property Tax (divide by 12):	$
Total of Fixed Monthly Expenses:	**$**

Budget Exercise Four: Estimating Recurring Expenses

RECURRING EXPENSES

These are expenses that are paid either monthly or quarterly, which are not a fixed amount and often change from month to month.

Bills that you must pay every month. This amount may fluctuate.	
Water (utility):	$
Cable/Netflix/other:	$
Gas/Heat (Utility):	$
Electric (Utility):	$
Cell Phone:	$
Land Line Phone:	$
Trash Pick Up:	$
Recycling Pick up:	$
Sewer (Utility):	$
Credit Card Debt:	$
Debit Card Fees:	$
Banking Fees:	$
Total	**$**

Other costs incurred but that may vary and change over the course of your life.

Food/Groceries:	$
Child Care/Babysitting:	$
Pre-School Tuition:	$
After-School Care:	$
Private School Tuition:	$
Education:	
- Related Costs (tutoring, etc.):	$
- Special Programs:	$
Total of Recurring Expenses:	**$**

Budget Exercise Five: Recurring Monthly Expenses

MEDICAL, DENTAL, AND INSURANCE COSTS

Health Insurance Monthly Premium:	$
Life Insurance (paid every quarter):	$
Disability Insurance (paid every quarter):	$
Medical Care Costs Not Covered by Insurance (includes deductibles, co-pays, out-of-pocket expenses):	$
Prescription Drugs and Over-the-Counter Costs Not Covered by Insurance (includes deductibles, co-pays, out-of-pocket expenses):	$
Dental Care Costs Not Covered by Insurance (includes deductibles, co-pays, out-of-pocket expenses):	$
Vision Care Costs Not Covered by Insurance (includes deductibles, co-pays, out-of-pocket expenses):	$
Total of Necessary Expenses:	**$**

OPTIONAL AREAS BASED UPON YOUR LIFESTYLE (MONTHLY)

Haircuts, Massage, Manicure, Pedicure:	$
Fitness Expenses:	$
Toiletries:	$
Dining Out and Take Out:	$
Pet Care (vet, food, etc.):	$
Dry Cleaners:	$
Residential Cleaning Service:	$
Transportation/Car Costs (public transportation fee for train/tolls/cabs; may or may not vary month to month):	$
Charitable Donations:	$
Membership Fees:	$
Dry Cleaners:	$
Residential Cleaning Service:	$
Long-Term Health Insurance Premium:	$
Computer Costs:	$
Legal Costs:	$
Accountant/Other Professionals:	$
Monthly Child Support:	$
Monthly Alimony:	$
Total of Optional Areas Based Upon Your Lifestyle (Monthly):	**$**

COSTS OF AUTOMOBILE(S) OWNERSHIP

Monthly Fuel:	$
Monthly Lease/Loan:	$
Car Insurance (paid every quarter):	$
Parking Meter Fee or Parking Garage Fee:	$
Car Inspection Fee:	$
Emissions Fee:	$
License Fee/License Renewal Fee:	$
Maintenance and Repairs:	$
Total of Costs of Automobile(s) Ownership:	**$**

Dr.
Patty / Ann

Budget Exercise Six: Discretionary Spending
DISCRETIONARY SPENDING

This is money to be spent at your discretion, because it is not used to pay any fixed, recurring, and/or fluctuating costs. Discretionary money is the money you have after all your bills that must be paid have been paid. In other words, discretionary money is fun money! So have fun spending it!

Vacation/Travel:	$
Entertainment: (includes theater, movies, ball games, dinner and all meals not eaten at home):	$
Charity/Donations/Fundraising Events:	$
Gifts for Family and Friends:	$
Instrument/Sports Lessons and Programs:	$
Boy and Girl Scout Dues:	$
Newspapers/Magazines/Books/Ebooks:	$
Total of Discretionary Spending:	$

Go to relationshiptoolbox.com/money-book/budget charts.pdf to download these budgetary money sheets.

Once you've itemized and totaled the amount of money you bring in and the amount of money that goes out every month, you

are now ready to create a budget that fits your unique lifestyle and goals.

Wait a minute! Maybe once you've added up your two money columns you realized the amount of money going out is greater than the amount of money coming in! Lo and behold, you've got a cash flow problem!

Budget Exercise Seven: Cash Flow—Do You Have Enough?

If the amount of money that goes out exceeds the amount of money that comes in, you have what is referred to as a cash flow problem. It is remedied by looking at your non-fixed costs and seeing where you can cut back and spend less money. You are hardly alone if you find this difficult to do.

If you are having difficulty with your cash flow, it will serve you well to remember the difference between a need and a want. Most budgets get busted on purchasing "wants" as opposed to "needs." If we are honest with ourselves, we really have very few "needs"! Consider a "need" to be an essential or a "must-have" for living. "Needs" consist of three basic elements: food, shelter, and clothing. That's it!

Living in a society where consumerism is out of control, we often escalate a "want" to a "need," making it difficult to differentiate between the two. For example, we "need" shelter, but we often "want" a five-bedroom house with a two-car garage and a pool. See the difference and the obvious ramifications for your budget? Needs and wants are very individualized, *what you really feel you need may actually be a want that you can live without.*

Utilizing the chart below, make a list of what you consider your needs and wants, and don't be surprised if that list changes over time. What you absolutely NEED in your twenties is sure different

than when you are forty. And when you change jobs, have a kid, get married, or get divorced, or have any major life event, your needs and wants will fluctuate and change with them. That's normal. It's an ongoing conversation to have with yourself and your significant other, if appropriate.

NEEDS	WANTS

Review your budget regularly, and adjust it as your life changes. It isn't set in stone. You don't do it once and then never again, otherwise, it's just an exercise in a book. Once you've created your budget, think of it as a malleable tool, one that changes over your lifetime as your goals change. For example, if you have budgeted for college tuition, once your kids are out of college, this budgetary item will no longer be valid; your financial goals and budget will shift.

Budgeting provides you with a tool to proactively embrace your financial situation and increase your wealth. The more money you

earn, the more you can positively impact your family and the world. You can take that truth to the bank (pun intended). There is absolutely nothing about struggling to make a living that makes the world a better place. Nothing!

If you earn what you are worth and budget your money accordingly, you can create a legacy that will dramatically improve the lives and happiness of the people you love and the people around the world, while simultaneously increasing your own happiness!

As you certainly know by now—Money *Can* Buy You Happiness!

CONCLUSION

"My will shall shape the future. Whether I fail or succeed shall be no one's doing but my own. I am the force. I can clear any obstacle before me or I can be lost in the maze. My choice. My responsibility. Win or lose; only I hold the key to my destiny."
—Elaine Maxwell

In the final analysis, what is life all about? For me and I hope for you, too, it is all about relationships. That being said, money does in fact make the world go round, and to ignore this reality is just plain naïve. Yet that is exactly what many hardworking women have done for decades. It is my sincere hope this book has empowered women to no longer run away from money and the conversations surrounding it, but to embrace it wholeheartedly on all fronts—in their personal and professional lives. I also hope this book has enabled women to stop apologizing for wanting to make money and get rich.

The goal of this book has been to close the gender wage gap and increase women's financial literacy by providing realistic, practical, and sound negotiating skills and strategies that will help women get paid what they are worth, and achieve financial security and wealth. For me, the

goal of wealth accumulation is not about flaunting money; it is about using money as a tool to enhance your life, the lives of the people you love, and the world at large.

Now that you have read this book, I hope you will agree with the message of its title: *Money Can Buy You Happiness* by the choices it affords you. Money opens doors that would otherwise seem elusive and remain shut to you. Money also makes you happy by providing you with the opportunity to live the life you want, whatever that means for you, and the opportunity to provide comfortably for the people you love.

Having the means to financially support the causes and charities you care passionately about will certainly increase your happiness!

Fortified with all the information you have learned in this book, I task you with the mission to go out there and get paid what you are worth! Once you have reaped your financial reward, you will have the responsibility to make the world a better place—what could possibly be wrong with that picture?

Feel free to contact me at info@relationshiptoolbox.com and send me a message about all your financial successes, promotions, raises, new businesses, and any other types of happiness only money can afford to bring into your life. Please write "Money Book" in the subject line. I'll celebrate right along with you!

Patty / Ann

78 FINANCIAL TERMS YOU NEED TO KNOW

The financial industry is no different from any other industry, in so far as it has its own unique language and corresponding definitions. Therefore, I would be remiss if this book did not include some basic financial terms and definitions essential to understanding the financial landscape you are preparing to embark upon. To facilitate your growth towards financial security, I've compiled seventy-eight basic financial terms and their accompanying definitions women must know. Feel free to reference these words when reviewing your financial statements, and/or contemplating your investment strategies.

In no way is the information provided in this glossary considered to be investment advice of any kind. The financial definitions provided are for informational purposes only. Before you make any investment decisions it is strongly recommended you consult with a certified/licensed financial advisor.

1. **Annual Percentage Rate (APR):** The interest rate for a whole year, rather than just for a month, as applied to a loan, mortgage loan, credit card, etc.

2. **Annual Report:** A comprehensive report on a company's activities throughout the preceding year.

3. **Asset:** Property owned by a person or company.

4. **Balance:** Money that remains in a financial account.

5. **Balance Sheet:** A financial statement that summarizes a company's assets liabilities and shareholders' equity at a specific point in time.

6. **Bear Market:** Market condition in which the prices of securities are falling, and widespread pessimism causes the negative sentiment to be self-sustaining.

7. **Bond:** Debt security in which the borrower owes the lender a debt and, depending on the terms of the bond, is obliged to pay them interest and/or repay the principal at a later date.

8. **Bottom Line:** The final total of an account, balance sheet, or other financial document.

9. **Budget:** A quantitative expression of a plan for a defined period of time.

10. **Bull Market:** Market condition in which the prices of securities are rising, and widespread optimism causes the positive sentiment to be self-sustaining.

11. **Capital:** Financial assets or the financial value of assets, such as cash.

12. **Capital Gains:** A profit that results from the disposition of an asset, such as a stock, bond, or real estate, where the amount realized on the disposition exceeds the purchase price.

13. **Cash Equivalents:** Assets that are readily converted into cash; these equivalents have a short-term existence.

14. **Cash on Hand:** Funds that are immediately available to a business that can be spent as needed.

15. **Cash Reserve:** The money that a company or individual keeps on

hand to meet its short-term and emergency funding needs.

16. **Certificate of Deposit (CD):** A time deposit, similar to a savings account, except CDs have a fixed term (monthly, three months, six months, or one to five years) and, usually, a fixed interest rate.

17. **Compound Interest:** Interest that is added to the principal of a deposit or loan so that the interest that has been added also earns interest.

18. **Concentration Ratio:** A ratio that indicates the relative size of firms in relation to their industry as a whole.

19. **Cost of Capital:** A term used in the field of financial investment to refer to the cost of a company's funds (both debt and equity).

20. **Coupon Rate:** The yield that the bond pays on its issue date; calculated by adding the total amount of coupons paid per year and dividing by the bond's face value.

21. **Credit:** The trust that allows one party to provide resources to another party where that second party does not reimburse that first party immediately (thereby creating a debt), but instead arranges either to repay or return those resources (or other materials of equal value) at a later date.

22. **Credit Card:** A card issued by a financial company giving the holder the option to borrow funds, usually at point of sale.

23. **Credit Rating:** An evaluation of the credit worthiness of a debtor or a potential client.

24. **Credit Union:** A member-owned financial cooperative, democratically controlled by its members, and operated for the purpose of promoting thrift, providing credit at competitive rates, and providing other financial services to its members.

25. **Debit Card:** A payment card that provides the cardholder access to his or her bank account at a financial institution.

26. **Depreciation:** The decrease in value of assets.

27. **Discretionary Income:** Money spent on non-essential goods or services.

28. **Dividends:** Distribution of a portion of company's earnings, decided by the board of directors, to a class of its shareholders.

29. **Dow Jones Industrial Average (DJIA):** A price-weighted average of 30 significant stocks traded on the New York Stock Exchange and the Nasdaq. The DJIA was established in 1896 by Charles Dow.

30. **Earnings Before Interest, Taxes, Depreciation, and Amortization (EBITDA):** An accounting technique EBITDA—earnings before interest, taxes, depreciation and amortization—is an important standard measure of profitability.

31. **Earnings Per Share (EPS):** The dollar value of earnings per each outstanding share of a company's common stock.

32. **Entrepreneur:** A person who organizes and operates a business or businesses, taking on greater than normal financial risks in order to do so.

33. **Equity:** Money obtained from investors in exchange for ownership of a company.

34. **Exchange Rates:** The value of one currency for the purpose of conversion to another.

35. **Fixed Costs:** A cost that doesn't change (rent, salary, etc.).

36. **Generally Accepted Accounting Principles (GAAP):** Standards, conventions, and rules that accountants follow in recording and summarizing, and in the preparation of financial statements.

37. **Grant:** Non-repayable funds disbursed by one party, often a government department, corporation, foundation, or trust, to a recipient, often a nonprofit entity, educational institution, business, or an individual.

38. **Gross Income:** An individual or company's total income before taking taxes and deductions into account.

39. **Gross Margin:** The percent of total sales revenue that a company keeps after subtracting the costs of producing its goods or services.

40. **Income Statement:** A financial statement that measures a company's financial performance over a specific accounting period.

41. **Income Tax:** A tax imposed on individuals or entities that varies with the incomes or profits of the taxpayer.

42. **Index:** A statistical measure of change in an economy or a securities market.

43. **Inflation:** A sustained increase in the general price level of goods and services in an economy over a period of time.

44. **Initial Public Offering (IPO):** Shares of stock in a company are sold to the general public, on a securities exchange, for the first time.

45. **Interest:** Fee paid by a borrower of assets to the owner as a form of compensation for the use of the assets.

46. **Interest Rate:** The rate at which interest is paid by the borrower for the use of money that they borrow from a lender.

47. **Internal Rate of Return:** Used in capital budgeting to measure and compare the profitability of investments; internal refers to the fact that its calculation does not incorporate environmental factors.

48. **Leverage:** The amount of debt that can be used to finance your business' assets.

49. **Liability:** An obligation of an entity arising from past transactions or events, the settlement of which may result in the transfer or use of the assets, provision of services, or other yielding of economic benefits in the future.

50. **Long-Term Investment:** An account on the asset side of a company's balance sheet that represents the investments that a company intends

to hold for more than a year. They may include stocks, bonds, real estate, and cash.

51. **Market Research:** An organized effort to gather information about target markets or customers.

52. **Market Share:** The percentage of a market accounted for a specific entity.

53. **Mutual Fund:** Operated by money managers, who invest in the company's capital and attempt to produce capital gains and income for the fund's future investors.

54. **NASDAQ:** The second-largest stock exchange in the world by market capitalization.

55. **Net Income:** A company's total earnings or profits.

56. **Net Profits:** A measure of profitability of a venture after accounting for all costs.

57. **Net Worth:** Total assets minus total outside liabilities of an individual or a company.

58. **New York Stock Exchange (NYSE):** The largest stock exchange in the world by market capitalization, sometimes referred to as the "Big Board."

59. **Principal:** The original amount invested, separate from earnings.

60. **Publicly Owned Company:** A company that has issued securities through an initial public offering (IPO) and is traded on at least one stock exchange or in the over-the-counter market.

61. **Return on Investment (ROI):** The concept of an investment of some resource yielding a benefit to the investor; one way of considering profits in relation to capital invested.

62. **Share:** The unit of ownership interest in a corporation or financial asset.

63. **Shareholder:** A person, company, or other institution that owns at least one share in a company.

64. **Short-Term Investment:** An account in the current assets section of a company's balance sheet. This account contains any investments that a company has made that will expire within one year.

65. **Statement of Cash Flows:** A financial statement that shows how changes in balance sheet accounts and income affect cash and cash equivalents; basically shows how cash flows in and out of a business.

66. **Standard & Poor's 500:** An index of 500 stocks chosen for market size, liquidity, and industry grouping, among other factors.

67. **Stocks:** Represents the residual assets of the company that would be due to a stockholder after discharge of all senior claims, such as secured and unsecured debt.

68. **Stockbroker:** Agent that charges a fee or commission for executing buy and sell orders submitted by an investor.

69. **Stock Market:** The market in which shares of publicly held companies are issued and traded, either through exchanges or over-the-counter markets.

70. **Stock Options:** A privilege, sold by one party to another, that gives the buyer the right, but not the obligation, to buy or sell a stock at an agreed-upon price within a certain period or on a specific date.

71. **Take-Home Pay:** The pay received by an employee after the deduction of taxes and other obligations.

72. **Tax:** A financial charge or levy imposed upon a taxpayer by a state (or functional equivalent of a state) such that failure to pay, or evasion of or resistance to collection, is punishable by law.

73. **Tax Deductible:** A deduction from gross income that arises from various types of expenses incurred by a taxpayer, decreasing the amount of taxes he or she owes to the government.

74. **Tax Rate:** The tax imposed by the federal government and some states based on an individual's taxable income or a corporation's earnings.

75. **Total Debt:** Loans from banks or others that must be repaid over time.

76. **Variable Costs:** Costs that are subject to change and fluctuation.

77. **Wall Street:** An eight-block street in Lower Manhattan in the financial district of New York City, which has become synonymous with financial markets in general.

78. **Working Capital:** A financial metric that represents operating liquidity available to a business, organization, or other entity, including a governmental entity.

BIBLIOGRAPHY

AAUW. "What Does Race Have to Do with a Woman's Salary? A Lot." *AAUW.org.* April 26, 2013.

Adams, Susan. "The Best-Paying Cities for Women in 2014." *Forbes. com.* *http://www.forbes.com/sites/susanadams/2014/02/03/the-best-paying-cities-for-women-2014.*

Adams, Susan. "Money Does Buy Happiness Says New Study." *Forbes. com.* http://www.forbes.com/sites/susanadams/2013/05/10/money-does-buy-happiness-says-new-study/ (Accessed August 15, 2015.)

Babcock, Linda, and Sara Laschever. *Women Don't Ask: The High Cost of Avoiding Negotiation and Positive Strategies for Change.* New York, NY: Bantam, 2007.

Babcock, Linda, Sara Laschever, Michele Gilfand, and Deborah Small. "Nice Girls Don't Ask." *Harvard Business Review.* https://hbr.org/2003/10/nice-girls-dont-ask

Babcock, Linda. "You Won't Get a Raise If You Don't Ask For One!" *Http://blogs.wsj.com/atwork.* N.p., n.d. Accessed August 16, 2015.

Barsh, Joanna, and Lareina Yee. "Unlocking the Full Potential of Women at Work." *Home.* N.p., 30 Apr. 2014. Accessed August 16, 2015.

Barsh, Joanna, and Lareina Yee. "Unlocking the Full Potential of Women in the US Economy." *Unlocking the Full Potential of Women in the US Economy.* McKinsey Consulting Firm: April 2011.

Blackmore, Claire. "Why Women Just Can't Say No..." *Marie Claire.* N.p., January 21, 2014. http://www.marieclaire.co.uk/blogs/544776/5-reasons-why-women-just-can-t-say-no.html

Bolles, Richard Nelson. *What Color Is Your Parachute? A Practical Manual for Job-hunters and Career-changers.* New York: Random House, 2014.

Casserly, Meghan. "The Real Origins Of The Gender Pay Gap—And How We Can Turn It Around." *Forbes.com.* July 5, 2012.

Chahal, Gurbaksh. "Always Be Closing: 11 Proven Ways To Become The Most Successful Closer." *Elite Daily, Comments.* N.p., April 7, 2014.

Chatzky, Jean Sherman. *You Don't Have to Be Rich: Comfort, Happiness, and Financial Security on Your Own Terms.* New York: Portfolio, 2003.

Collins, Victoria F., and Suzanne Blair. Brown. *Couples and Money: Why Money Interferes with Love and What to Do about It.* New York: Bantam, 1990.

DeSilva, Tiffany. "10 Signs Your Baggage Is Hurting Your Business." BrightFire Women's Business Network, LLC. N.p., n.d. March 28, 2014. http://www.brightfirenetwork.com/10-signs-your-baggage-is-hurting-your-business

"Do Women Outearn Men in the United States? The Facts." *Catalyst.* October 16, 2012.

Drew, Chloe. *The Salt Lake Chamber.* N.p., n.d. http://slchamber.com/blog/tag/woman

Duberman, Amanda. "Why It's Harder For Women To 'Brag' About Themselves At Work— And Why We Really Need To." *TheHuffingtonPost.com*, January 22, 2014.

Dugan, Dawn. "7 Salary Negotiation Tips for Women—How to Get Ahead Without Negative Feedback." *Salary.com*. N.p., n.d.

Dunn, Elizabeth, and Michael I. Norton. *Happy Money: The Science of Smarter Spending*. New York: Simon & Schuster, 2013.

Dweck, Carol S. *Mindset: The New Psychology of Success*. New York: Random House, 2006.

Dykman, April. "An Early Education in Financial Literacy." *Forbes.com*. October 25, 2011.

ERI. N.p., n.d. [??]

"Facts for Features." *Facts for Features*. United States Census Bureau. Accessed August 28, 2015.

Glassdoor. N.p., n.d. Web. http://glassdoor.com/index.htm

Glynn, Sarah Jane, and Audrey Powers. "The Top 10 Facts About the Wage Gap." The Center for American Progress. April 16, 2012.

Goleman, Daniel. *Emotional Intelligence: Why It Can Matter More than IQ*. New York, New York: Bantam, 1994.

Harris, Russ. *The Happiness Trap: How to Stop Struggling and Start Living*. Boston, Massachusetts: Trumpeter Books, 2007.

Harvard Business Review—Ideas and Advice for Leaders. N.p., August 25, 2015. Web.

Hendershott, Hilary. *Hilary Hendershott Financial*. N.p., n.d.

"Home: Occupational Outlook Handbook: U.S. Bureau of Labor Statistics." U.S. Bureau of Labor Statistics. January 8, 2014. [LIST UNDER US BUREAU]

"How Come Women Negotiate Differently than Men?" *Practical PM Journal*. N.p., June 26, 2013.

Huffington, Christina. "Women And Equal Pay: Wage Gap Still Intact, Study Shows." *TheHuffingtonPost.com*. April 9, 2013.

JobStar Guide to Salaries. http://jobstar.org/tools/salary/index.php.Kogan, Nataly. "Yes, Money Can Make You Happier." May 24, 2013.

Korn, Melissa. "You Won't Get a Raise If You Don't Ask For One!" *At Work RSS*. The *Wall Street Journal.com*. May 30, 2013.

Linn, Allison. "For Women, Asking for a Raise Can Backfire." *CNBC.com* N.p., November 27, 2013.

Ludden, Jennifer. "Ask For A Raise? Most Women Hesitate." *NPR.com*February 8, 2011.

McCullough, Bonnie Runyan. *Bonnie's Household Budget Book: The Essential Guide for Getting Control of Your Money.* New York: St. Martin's Griffin, 2001.

Miller, Lee E., and Jessica Miller. *A Woman's Guide to Successful Negotiating: How to Convince, Collaborate, and Create Your Way to Agreement, 2nd ed.* New York, NY: McGraw-Hill, 2010.

Miller, Lee. "Three Mistakes Women Make When Negotiating Salary. *Monster.com*. Monster Career Advice. N.p., n.d.

Montini, Laura. "The Basics of Business Body Language (Infographic)." *Inc.com*. N.p., July 21, 2014.

MyPlan.com: Home. N.p., n.d.

Nardella, Anna. "Female Negotiation." PWN Global, n.d. http://www.europeanpwn.net/index.php?article_id=70

The National Bureau of Economic Research. http://www.nber.org/.

Nelson, Audrey. "Can Men Play the Negotiation Game Better than Women?" *PsychologyToday.com* June 19, 2011. Web.

Nelson, Brett. "Financial Illiteracy Is Killing Us." *Forbes.com.*, August 24, 2010.

Noguchi, Yuki. "50 Years After The Equal Pay Act, Gender Wage Gap Endures." *NPR.com*. June 10, 2013.

National Women's Law Center. "NWLC Analysis Shows Striking Racial and Ethnic Disparities in Gender Wage Gaps." http://www.nwlc.org/press-release/nwlc-analysis-shows-striking-racial-and-ethnic-disparities-gender-wage-gapsApril 4, 2013.

U. S. Bureau of Labor Statistics."Occupational Employment Statistics Contacts.". March 25, 2015.

PsychologyToday.com N.p., n.d.

Pynchon, Victoria. "Be the Smartest Kid on Negotiation Block by Framing and Anchoring." *RSS*. N.p., June 29, 2014.

Pynchon, Victoria. "The Power of Framing and Anchors." Negotiation Law Blog. *Southern California Arbitration Mediation & Conflict Resolution: Settle It Now Dispute Resolution Services: Serving Los Angeles, Beverly Hills, Century City*. N.p., June 25, 2007.

Pynchon, Victoria. "The Ultimate Guide to Getting What You Want." *Linkedin.com* September 12, 2014.

Pynchon, Victoria. "Why Every Woman Should Ask for a Raise This Year." Forbes.com January 22, 2011.

R, Srinivasan. "Are You A Skilled Negotiator?" *Linkedin.com* August 18, 2014.

Ryan, John R. "What's Your Leadership Mindset?" *Bloomberg.com/BusinessWeek*. June 19, 2009.

Ryan, Wendy, and Aaron Gouveia. "Why Women Don't Negotiate." *Salary.com*. n.d.

Salary.com. N.p., n.d. http://www.salary.com/why-women-don't-negotiate.

Sandberg, Sheryl, and Nell Scovell. *Lean In: For Graduates*. New York, NY: Random House, 2013.

Sandberg, Sheryl. *Lean In: Women, Work, and the Will to Lead.* New York, NY: Random House, 2013.

Sauter, Mike. "Jobs with the Widest Pay Gaps between Men and Women." *Finance.yahoo.com.* November 6, 2013.

Sealey, Geraldine. "Women & Money, Why You Need To Take Control Now."*Real Simple.com.* N.p., September 2012.

Sekar, Anisha. "How Money CAN Buy You Happiness." *U.S. News & World Report.* September 17, 2013.

Shellenbarger, Sue. "Why Likability Matters More at Work." *WSJ. com.* March 25, 2014.

Shriver, Maria. "Why Women Must Lean In and Push Back." Weblog post. *TheHuffingtonPost.com.* March 7, 2013. Accessed August 28, 2015.

Smith, Jessi. "Women's Bragging Rights." *Psychology of Women Quarterly.* December 20, 2013.

Sommers, Christina Hoff. "No, Women Don't Make Less Money Than Men." *The Daily Beast.com.* February 1, 2014.

Spangler, Brad. "Integrative or Interest-Based Bargaining—Beyond Intractability." June 2003. www.beyondintractability.org/essay/interest-based-bargaining

Stouffer, Tere. *The Only Budgeting Book You'll Ever Need.* Avon, MA: Adams Media, 2012.

Thompson, Derek. "Money Buys Happiness and You Can Never Have Too Much, New Research Says." *TheAtlantic.com.* April 29, 2013. Accessed August 15, 2015.

Tublin, Dr.Patty Ann. *Not Tonight Dear, I've Got a Business to Run! Enrich Your Marriage While Prospering in Your Business.* USA: Vervante, 2012.

Ventura, John, and Mary Reed. "Defining Differences between Bad

Debt and Good Debt." Managing Debt *For Dummies*. http://www.dummies.com/how-to/content/get-to-know-types-of-credit.html

WashingtonPost.com.

"What Is Brain Plasticity?" *BrainHQ.*

"When To Make the First Offer In Negotiations." *Harvard Business Review*. 8 Aug. 2004. Web.

Williams, Geoff. "Are Women Lousy Salary Negotiators?" *U.S. News Money.* http://money.usnews.com/money/personal-finance/articles/2013/07/02/are-women-lousy-salary-negotiators July 2, 2013.

"Women Want To Be Liked: 3 Shocking Reasons Why We Fear Salary Negotiations." *Womens Personal Finance Girls Just Wanna Have Funds.* http://www.girlsjustwannahavefunds.com/women-salary-negotiation-fear/ Accessed August 16, 2015.

"Women's Earnings and Income." *Catalyst.com*. October 10, 2012. Accessed August 8, 2015.

Young Entrepreneurial Council. "11 Body Language Essentials for Your Next Negotiation." *Inc.com.* July 29, 2014.

Zhou, Hui, and Tinguin Zhang. "Body Language in Business Negotiation." *International Journal of Business and Management* Vol 3. No2 90. February 2008

KEYNOTE SPEAKING TOPICS

http://www.relationshiptoolbox.com/money-book-speaking/

Secrets for Cashing In
What Every Women Needs to Know to Get
Paid What They Are Worth!

Although it has been more than half a century since the passage of the Equal Pay Act of 1963, the gender wage gap persists, with women earning approximately seventy-seven cents for every dollar a man makes. While there are many external barriers contributing to this pay inequity, women must take individual responsibility and let go of the factors that inhibit their ability to insist they get paid what they are worth.

This presentation will show you exactly what you need to do to get paid what you are worth by:

- ✓ Understanding how your mindset is a huge barrier for getting paid—or charging—what you are worth
- ✓ Learning the difference between how men and women negotiate, and taking a page out of the guys' negotiation play book

✓ Using proven negotiation strategies and techniques to get paid what you deserve!

Emotional Intelligence & Its Influence on Leadership

A high level of Emotional Intelligence (E.I.) is not a luxury but a prerequisite for success in both our professional and personal lives. In today's highly competitive, fast-paced work environment, the organizations that will succeed and thrive are those that recognize and develop the Emotional Intelligence of all its employees.

During this presentation you will learn:

✓ Specifically what Emotional Intelligence (E.I.) is and why you should care

✓ The relationship between I.Q. and E.I., and how it relates to your success in business and life

✓ Three proven strategies to increase your Emotional Intelligence

FINALLY! *The Truth About Work-Life Balance*

Women have been working outside the home for over a half-century, yet we continue to struggle to make it all happen. If work-life balance is the key to "having it all," why does it remain such an elusive goal for so many people?

How do you create a successful business/career without sacrificing happiness in your marriage and personal life?

Following this keynote presentation you will immediately be able to:

✓ Create a proven system for reconciling your professional and personal responsibilities

- ✓ Learn three key components you must have in your personal/family plan that complements, rather than competes with, your professional/business plan
- ✓ Learn and use effective communication skills for success in business and life

DR. PATTY ANN'S SERVICES

http://www.relationshiptoolbox.com/money-book-services/

Dr. Patty Ann Tublin is available for the following services:

Negotiation Package

"NO!" is just the beginning of your negotiation. Utilize a proven step-by-step system to negotiate a killer compensation package tailored to your unique needs.

Executive Coaching Package

Recognized as being an expert on Emotional Intelligence (E.I.) and relationship skills, Dr. Patty Ann will provide executive coaching to help each professional perform at an optimal level in today's workplace. By partnering with each individual client in a strategic manner, goals are clarified, prioritized, and achieved.

Workshops and Seminars

Topics include but are not limited to:

Emotional Intelligence

Emotional Intelligence (E.I.) is the ability to understand the relationship between emotions and behavior. Organizations realize their most effective leaders and highest-performing team members possess a high level of E.I.

Participants who attend this workshop will:

✓ Learn exactly what E.I. is and why it matters to your success

✓ Discover three key ways to increase your E.I. competency

✓ Identify personal limitations and strengths

Communication

Effective communication skills have never before been more critical to the success of your business. It is the cornerstone upon which organizational and individual success is built.

This communication workshop/seminar will demonstrate how to:

✓ Communicate clearly and precisely

✓ Prevent miscommunication that costs millions of dollars in misappropriated or lost revenue

✓ Teach effective communication skills for both electronic and face-to-face interactions

✓ Strengthen relationships that optimize interpersonal relationships and overall performance

Conflict Resolution

Every work environment faces conflict on a daily basis. Acknowledging and effectively resolving these conflicts is critical for success.

Following this seminar, attendees will be able to:

✓ Understand the value of healthy conflict in the workplace

✓ Resolve conflict in a manner that increases efficiency for both the team and the individual

✓ Enhance positive interactions

✓ Recognize and control emotional triggers

In addition to her corporate and entrepreneurial work, Dr. Patty Ann offers exclusive VIP Couples Days, VIP Couples Weekend, and Individual Consultations in person and remotely using an array of modern technology. To schedule any of these exclusive offerings, contact us at info@relationshiptoolbox.com, or call 1-877-456-7230.

DR. PATTY ANN'S PRODUCTS

http://www.relationshiptoolbox.com/money-book-products/

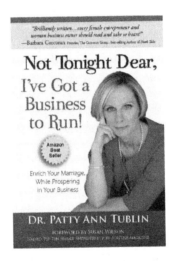

As an Amazon best-selling book, *Not Tonight Dear, I've Got a Business to Run! Enrich Your Marriage While Prospering in Your Business* quickly became the "go-to" resource for anyone seeking to create success in their business while keeping their marriage and family life intact.

Barbara Corcoran wrote: *"Dr. Patty Ann rolls up her sleeves to tackle what just may be the last frontier for women. . . . beautifully written and a practical jewel of a book that every entrepreneur and small business owner should read and take to heart!"*

Relationship Toolbox® Affirmation Cards

Affirmation Cards—All success begins with relationships! Your business success is greatly influenced by the success of your personal relationships. These cards provide a fun alphabetized (A–Z) guide for increasing happiness in your personal relationships. Played as a matching card game using never-before-revealed relationship affirmations. These cards are the perfect gift for all occasions.

Relationship Affirmation Playing Cards—A deck of playing cards. Enjoy playing any regular card game with your significant other. As added fun, every card includes an affirmation for you to read aloud, say silently to yourself, or make part of the game. Be creative! These cards make great gifts and party favors!

MONEY CAN BUY YOU HAPPINESS

Secrets Women Need to Know
to Get Paid What They Are Worth!

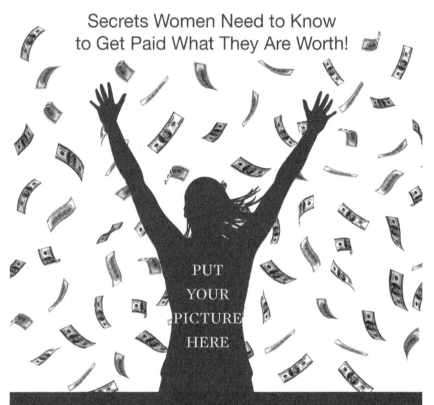

PUT
YOUR
PICTURE
HERE

DR. PATTY ANN TUBLIN